hiroshima after iraq

wellek library lectures

hiroshima after iraq

three studies in art and war

rosalyn deutsche

columbia university press

new york

Columbia University Press
Publishers Since 1893
New York Chichester, West Sussex
Copyright © 2010 Columbia University Press
Columbia University Press would like to express its appreciation to the Graham
Foundation for Advanced Studies in Fine Arts for assistance with the costs of
illustrations in this volume.

Library of Congress Cataloging-in-Publication Data

Deutsche, Rosalyn.
 Hiroshima after Iraq: three studies in art and war / Rosalyn Deutsche.
 p. cm.—(Wellek library lectures in critical theory)
 Includes bibliographical references and index.
 ISBN 978-0-231-15278-5 (cloth: alk. paper)
 1. Art and war. 2. Kolbowski, Silvia. After Hiroshima mon amour.
3. Wodiczko, Krzysztof. Hiroshima projection. 4. Thornton, Leslie, 1951–
Let me count the ways. I. Title. II. Title: Three studies in art and war.
III. Series.

 N8260.D48 2010
 700.1'03—dc22

 2010000457

Casebound editions of Columbia University Press books are printed on permanent
and durable acid-free paper.
Printed in the United States of America
c 10 9 8 7 6 5 4 3 2 1
References to Internet Web sites (URLs) were accurate at the time of writing.
Neither the author nor Columbia University Press is responsible for Web sites that
may have expired or changed since the book was prepared.

editorial note

The Wellek Library Lectures in Critical Theory are given annually at the University of California, Irvine, under the auspices of the Critical Theory Institute. The following lectures were given in May 2009.

The Critical Theory Institute
Kavita Philip, Director

To
Jennifer Hayslett
and
Elizabeth Miller

contents

acknowledgments

When I was about eight or nine years old I read the following letter, which had been written to my mother by my father, when he was waiting to return home from Germany after fighting in World War II.

June 3, 1945

Darling,

While typing a list of orders from our general, concerning carefulness about saluting officers, and such like, I day-dreamed about the following.

Edmund Goody was someone I knew in Croft. He was married and had a little child.

On the trip over he became attached to me. He said I was the only one he could talk to, and couldn't get over how I didn't seem to mind. He was in as bad a state as I have ever seen anyone. The idea that he was moving further and further away from his wife and child was driving him crazy. What were they doing? You didn't know whether they were sick or what?

And here he was in the infantry; going into battle. He would surely be killed and never see his wife and child again.

Sometimes I went to another part of the boat, just to avoid him; but he searched me out. What were we doing in the infantry? I, a school teacher, and he, an accountant. I tried to explain my ideas of life and the war to him. He said this made him feel better. In the Replacement Pool, in England, he was on the verge of collapse. When I took off for the 4th Armored, he felt I was getting a break. He wasn't getting any. Others, less qualified, were getting breaks. He was just going into the infantry to be killed. "My poor wife and child!" He wept when we parted, and made me promise that I would write.

He was the only one I have written to, and I wrote to him within a week. For a long time there was no answer.

In Normandy, just before the breakthrough, my letter came back with all kinds of official stamps and markings. Somewhere—tucked away among them—was the little word: DECEASED.

Jack

This man's story had a deep and long-lasting impact on me, and so I would like to thank my father, who started me thinking about the horror of war.

My sincere gratitude goes to the Critical Theory Institute at the University of California, Irvine, for inviting me to give the Wellek Library Lectures in May 2009. I was deeply honored. Special thanks to Kavita Philip, director, and Lisa Clark, administrative coordinator, whose warmth and hospitality made my visit to Irvine so delightful.

I appreciate Jennifer Crewe's guidance in transforming the lectures into a book and Susan Pensak's helpful copyediting.

Thanks also to the artists whose works inspired this work—Silvia Kolbowski, Leslie Thornton, and Krzysztof Wodiczko.

I am particularly grateful to my dear family and friends, whose intellectual and emotional support have been crucial to me during the writing of these essays and over the years: Robert Benton, Marielle Cohen, Marion Cohen, Douglas Crimp, Rita Dennis, Martha Gever, Benjamin

Hayslett, Ella Hayslett, Thornton Hayslett, Silvia Kolbowski, Anne Leiner, Marvin Leiner, Simon Leung, Aaron S. Metrikin, Fordon Miller, Stevens Miller, Robert Millner, Matt Mungan, Mignon Nixon, Yvonne Rainer, Ann Reynolds, Stephen Stancyzk, Lynne Tillman, Jane Weinstock, and Janet Wolff. Robert Ubell's sustenance continues to mean the world to me.

hiroshima after iraq

introduction

Maurice Blanchot said that political impatience makes criticism warlike. Driven by the urgency of human-inflicted disasters, we want to proceed straight to the goal of social transformation, and so, wrote Blanchot, the indirection of the poetic—and, we might add, the artistic—displeases us.[1] It should not be surprising, then, that the pressing events of the past eight years—war, rendition, torture—have produced many examples of impatient criticism. Two years ago, for instance, the journal *October* sent a questionnaire to a group of art world intellectuals, soliciting opinions on artistic opposition to the invasion and occupation of Iraq. *October*'s attempt to open up a conversation about art and war was welcome, but its survey suffered from the fallacy of the loaded question. It asked: "What, if anything, demotivates the current generation of academics and artists from assuming positions of public critique and opposition against the barbarous acts committed by the government of the United States against a foreign country?"[2] And, after noting that today "antiwar opposition seems most visible on the Internet" and asking if the "electronic-technological public sphere" measures up to the public protests of the Vietnam era, another question inquired whether this

condition implies a "fundamental transformation of the sense of a political public subject,"[3] a transformation that, in the context of the journal's comparison between the present and what it portrayed as an earlier golden age of protest, could only be viewed as a degeneration from activism to quietism. What emerged was a thinly disguised decline-and-fall jeremiad about opposition to war in which current antiwar activity appeared in an unfavorable light by contrast with that of the 1960s and seventies, when, as the editors put it, "agitprop cultural activities were organized through word of mouth, flyers, and planning meetings, and demonstrations were staged in the streets, in museums, and in a variety of print media."[4]

October published forty-two responses to its questionnaire in its Winter 2008 issue. The editors' introduction to this issue brought into the open what had remained implicit in the original questions, stating that addressees of the questionnaire had been asked to evaluate "the seeming absence of visible opposition within the milieu of cultural producers working in the sphere of contemporary visual culture." And although the editors claimed that the responses informed them of diverse forms of opposition to the war, they nonetheless continued to assert that "the role of academics, intellectuals, and artists in the cultural public sphere has been reduced to anesthesia and amnesia."[5]

October's impatience with current antiwar activity in art—and its paternal demand that younger generations identify with a supposedly authentic antiwar politics—is symptomatic of a more longstanding mood in art criticism, a mood that emerged in the late 1970s and that I have elsewhere called, following Walter Benjamin, left melancholy.[6] For Benjamin, left melancholy was an attachment to past political ideals that forecloses possibilities of political change in the present. In 2003 Wendy Brown used Benjamin's term to describe the emergence over the previous two decades of traditionalism in left politics.[7] She attributed this return to orthodoxy to, among other things, the rise of sexual politics. Reacting against feminist challenges to the notion that a pregiven economic foundation totalizes both society and emancipatory struggle, subordinating all other social struggles, the left melancholic, observed Brown, clings to "notions of unified movements, social totalities and class-based politics."[8]

When I suggest, after Blanchot, that today's politically impatient, left-melancholic criticism of war is itself warlike, I do not simply mean that it is, in some general sense, aggressive. Rather, I am thinking of Freud's characterization of war in his 1915 essay "Thoughts for the Times on War and Death." Freud commented on the shock and disillusionment evoked in "the citizen of the civilized world" by the First World War. Previously, he said, we had believed that, even if war broke out, courtesy and respect between nations and laws of war that distinguish between civilians and combatants would prevail. We are disillusioned, said Freud, because in this war the state "absolves itself from the guarantees and treaties by which it was bound to other states, and makes unabashed confession of its own rapacity and lust for power, which the private individual has then to sanction in the name of patriotism."[9] Freud's shock over the violation of standards of war may have been, as Michael Sherry puts it, "possible only for a generation that ignored the long record of horrors in centuries of war."[10] Freud, however, criticized his disillusionment from another point of view. Disillusionment, he said, is unjustified because what has been destroyed is, precisely, an illusion—or, rather, two illusions: that states are guardians of moral standards and that individual members of the highest human civilizations are incapable of brutal behavior. "In reality," wrote Freud, "our fellow-citizens have not sunk so low as we feared, because they had never risen so high as we believed."[11] Psychoanalysis offers the insight that every earlier development of the mind persists alongside the later stage that arises from it and, therefore, in mental development there is a special capacity for regression. War, Freud speculated, brings about such regression, a regression to aggressive impulses and to a capacity for barbarous deeds, which has not been eradicated in the individual but only held in check by a community that now sanctions it. In fact, "The individual citizen can with horror convince himself in this war of what would occasionally cross his mind in peace-time—that the state has forbidden to the individual the practice of wrong-doing, not because it desires to abolish it, but because it wants to monopolize it, like salt and tobacco."[12] What is more, said Freud, war is a regression not only to barbarism but also to "the instinctive and impulsive heroism" of the unconscious, which does not know its own death and "flouts danger in the spirit of . . . : 'Nothing can happen to *me.*'"[13] War,

in Freud's view, gives full play to grandiose fantasies of invincibility, which is to say, to heroic masculinism, understood as an orientation toward ideals of wholeness that disavow vulnerability.

In my response to *October*'s survey, I argued that regression to heroic masculinism in the current situation of war isn't confined to pro-war forces but extends to sectors of the left opposition, sectors that I have now identified as impatient and melancholic. Antiwar cultural criticism, that is, often uses the urgency of the Iraq and Afghanistan wars to legitimize a return to a totalizing political analysis, and this return has a narcissistic dimension, not only because it idealizes an earlier political moment with which the left melancholic identifies himself but also because, as Brown argued, this analysis once formed the basis of leftist self-love, giving "its adherents a clear and certain path toward the good, the right, the true."[14] Predictably, then, today's impatient criticism is impatient not only with the poetic or artistic, as Blanchot would have it, but also with feminist interrogations of the meaning of the political. For it was feminism, particularly psychoanalytic feminism, now often treated as a feminized luxury we can no longer afford, that explored the role played by totalizing images in producing and maintaining heroic, which is to say, warlike subjects.

As a corollary of its impatience with feminism, which has long insisted on the inseparability of the personal and the political and on a politics concerned with subjectivity, melancholic antiwar criticism tries to divide the subjective and the material, the public and the private, and the social and the psychic as though war has nothing to do with mental life, as though there is no work of the psyche in the waging of war. In this, antiwar criticism mimics dominant discourse about war: recall, for example, President Bush's assertion that he wasn't going to go on the couch about Iraq or Truman's statement after dropping the atomic bomb on Hiroshima: "I don't believe in speculating on the mental feeling."[15] Art historian Mignon Nixon has argued against this current refusal to understand war in psychic terms: "The habit of separating the psychical from the social," writes Nixon, "the individual subject from social subjectivity, even seems redoubled in times of war—as if waging war depends upon holding these terms apart. . . . Even now, in the political discourse surrounding the Iraq War, the psychical and the social are

split, even on the Left; as if to reflect on subjectivity in time of war were, in itself, to reject the political, even to diminish resistance to war." *October*'s survey seemed to raise the issue of subjectivity when it asked if the prevalence of antiwar activity on the Internet implies a transformation of the sense of a political public subject. But since the editors posed the question within a Habermasian framework, in which transformation of the public sphere is tantamount to a decline into passivity and privacy, they foreclosed the question of subjectivity—of subjectivity as a question—at the very moment they seemed to open it. They issued a plea to resuscitate a traditional notion of the political subject—unitary, preconstituted, and self-possessed, one who enters an equally traditional public space of protest—instead of recognizing a political subject that, as Simon Leung put it in his response, "is formed by the relationship between the self and the other in the polis."[16] *October* thus ignored the ways in which, for decades, the sense of a political subject has indeed been transformed not only by the Internet but by feminism, psychoanalysis, and poststructuralism. Warlike antiwar criticism's division of public and private is a weapon wielded, in the service of a fantasy of mastery, against uncertainty in the self and the exposure to otherness in public space.

Still, *October* posed a good question: What can art offer in the current situation of war? About twenty years ago, the British analyst Hanna Segal, cofounder of Psychoanalysts for the Prevention of Nuclear War, addressed a similar question to her field. Writing about the threat of nuclear war, Segal asked, "What can psychoanalysis possibly offer in such a situation?" Her answer: "It is not pathological to hope for a better future—for instance, peace—and to strive for it, while recognizing how hard it is to attain, and that the opposition to it comes not only from others but also has its roots in ourselves."[17] Psychoanalysis, said Segal, can help us understand the intimate connection between war and what she called psychic facts, which include our own aggressive impulses. Twenty years earlier, Wilfred R. Bion, a follower, like Segal, of Melanie Klein and an elaborator of Freud's ideas about group psychology, also suggested that psychoanalysis has something to say about social problems: "Society, like the individual, may not want to deal with its distresses by psychological means until driven to do so by a realization that

some at least of these distresses are psychological in origin."[18] Still earlier, in 1934, Roger Money-Kyrle, another Kleinian analyst, also responded to Segal's question, writing that the more we realize how the destructive impulses that break out in war are always present in our unconscious minds, "the more likely we shall be to take all possible precautions."[19] And recently, in an essay that brings Freud's ideas to bear on Abu Ghraib, Jacqueline Rose echoed the Kleinians: "It is a central tenet of psychoanalysis," writes Rose, "that if we can tolerate what is most disorienting—disillusioning—about our own unconscious, we are less likely to act on it, less inclined to strike out in a desperate attempt to assign the horrors of the world to someone, or somewhere, else. It is not . . . the impulse that is dangerous but the ruthlessness of our attempts to be rid of it."[20]

These authors, by contrast with politically impatient art critics, articulate a critique of subjectivity with a critique of concrete political phenomena, in this case, the phenomenon of war, suggesting that to refuse the interpretive power of psychoanalysis in dealing with violence and to attempt to come to terms with war by working only with conscious processes is to fail to take account of how resistant, deep, and enduring war is. What is socially and historically relative about specific wars needs to be thought in relation to what the Italian analyst Franco Fornari, author of *The Psychoanalysis of War,* called "war as a specific social institution," one that persists beyond any single social formation. Fornari disputed the oft-expressed thesis that the psychoanalytic approach to war is nonspecific because it is metahistorical, arguing instead that, whereas economic, political, and ideological factors are specifically generators of conflicts, they are not specific factors of war. When conflicts are expressed in the form of war, said Fornari, it means that a new fact has come into existence.[21] Tracing this new fact to the subject, he urged us to take responsibility for our unconscious, which I take to mean not only acknowledging the psychic dimensions of war but, as Rose advocates, avowing what is most disillusioning about ourselves.

In bringing together *October*'s question about art's relationship to war and Segal's corresponding question about psychoanalysis, I do not mean to elide the difference between the two fields. Yet, because contemporary art, especially since the 1980s, has stressed that a work of art

is not a discrete entity but, rather, a term in a relationship with viewers; because, in so doing, art has developed strategies for what Theodor Adorno called turning toward the subject; and because these strategies question the rigid forms of identity and triumphalist fantasies whose maintenance helps cause war, there is, I think, a convergence between contemporary art and psychoanalysis. Therefore answers to the questions about the two may have points of similarity. As a contribution to current discourse about art and war, I want to use these essays to explore art's ability to combine a concern for subjectivity with a concern about the problem of war and therefore to resist both dominant and left melancholic discourses. I'll conduct my exploration by discussing three contemporary artworks: all videos that have been shown in art institutions. The thematic content of each video is an act of war: the dropping of the atomic bomb on Hiroshima on August 6, 1945. One video—Krzysztof Wodiczko's *Hiroshima Projection* of 1999—was made after the first Gulf War; the other two—Silvia Kolbowski's *After Hiroshima mon amour* of 2005–2008 and Leslie Thornton's *Let Me Count the Ways* of 2004–2008—appeared after the U.S. invasion of Iraq and the launching of the "war on terror." Each video is a mnemonic representation that assumes the ethical task of addressing the historic disasters that, though unimaginable, nonetheless happen. Each engages a Benjaminian type of memory that creates a constellation between past and present, in this case, past and present wars. I'll begin with Silvia Kolbowski's *After Hiroshima mon amour*, a remake of sorts of Alain Resnais's *Hiroshima mon amour*, which was released in 1959, when the search for a modern cinema arose, at least in part, from the imperative of responding to a world made unrecognizable by war. In Resnais's film, a French woman and a Japanese man, each having suffered a World War II–related trauma, become lovers in Hiroshima, a quintessential site of trauma. Kolbowski's video is "after" *Hiroshima mon amour* in at least three senses: it is subsequent to, in imitation of, and in honor of the film. An abbreviated remake—like the other two works I'll be discussing, it is twenty-two minutes long—it also extends and elaborates some of the principal themes of its source.

one • silvia kolbowski

"We return to Hiroshima . . . to confront our own dark truths."[1] So write Robert Jay Lifton and Greg Mitchell in their 1995 book *Hiroshima in America*. The book's subtitle, *Fifty Years of Denial*, encapsulates its thesis: the United States has never faced its cruelty in using atomic weapons. Instead, ignoring the historical evidence, it has clung to an official narrative about Hiroshima, which, put in place in the postwar years, claims that the dropping of the bombs was necessary to end World War II and that it saved American and Japanese lives. There are of course notable exceptions to this denial. Consider, for example, George Kennan, who in 1982, writing about the nuclear threat, admonished us to remember that Americans were the ones who used the bomb "in anger against others, and against tens of thousands of helpless non-combatants": "Let us not in the face of this record, so lose ourselves in self-righteousness and hypocrisy," cautioned Kennan, "as to forget the measure of our own complicity in creating the situation we face today."[2] Consider also Allen Ginsberg, who in 1956 more succinctly declared, "America. . . . Go fuck yourself with your atom bomb . . . when will you be angelic?"[3] But, counternarratives notwithstanding, no American

president while in office has publicly questioned the resort to atomic warfare. In 1991, prior to the first Gulf War, a Gallup survey found a near majority backing the use of an atomic bomb against Iraq. In 1995 President Clinton asserted that Truman had made the right decision "based on the facts he had before him."[4] And the same year, when curators at the Smithsonian Institution's Air and Space Museum wanted to mark the anniversary of the bombing with an exhibition showing its effects on Japanese victims, the plan was aborted because of a tidal wave of protest from veterans as well as the mainstream press.[5]

Silvia Kolbowski's *After Hiroshima mon amour*, which, unlike its precursor text, is aimed primarily at an American audience, returns to Hiroshima to confront the legacy of the atomic bombing, linking it to the present of the invasion and occupation of Iraq. The video also ties these historically specific acts of war to what is often called war in general—what I prefer to call, following Fornari, "war as a specific social institution." *After Hiroshima mon amour* assembles a complex mixture of visual material, shaping it into a tightly structured meditation on war. The video is framed by footage, appropriated from its source film, on which the artist has performed certain mediating operations (figs. 1.1, 1.2), and which she has edited together with footage of war-torn Iraq and post-Katrina New Orleans (figs. 1.3, 1.4), footage gleaned from the Internet and suffused with computer-generated color that gives it the affective quality of what Gilles Deleuze terms the colour-image.[6] The video also contains live-action black-and-white scenes that mimic the framing and mise-en-scène of scenes in the original film, but in which the French woman and Japanese man are displaced by actors of various races, ethnicities, and nationalities and changes in costumes, hairdos, and music indicate a later time period (fig. 1.5). There is a staged and composited scene, saturated with red, of two sets of hands coloring in the emblem of the International Red Cross—a scene that suggests questions about humanitarian law and aid (fig. 1.6). And, finally, there are staged and unstaged color scenes shot by the artist, such as that of the lovers at an anti–Iraq War demonstration or those of the couple wandering through the city, scenes that evoke but do not replicate portions of the original film (figs. 1.7, 1.8, 1.9). Kolbowski overlays this array of visual elements with a text that mixes lines from Duras's script for *Hiroshima mon amour*

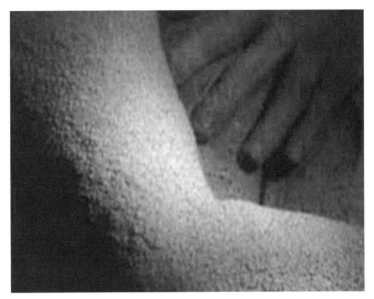

Fig. 1.1

Fig. 1.2

Silvia Kolbowski, *After Hiroshima mon amour*, 2005–2008, stills from black-and-white and color video. Unless otherwise noted, all the images in chapter 1 are from this video.

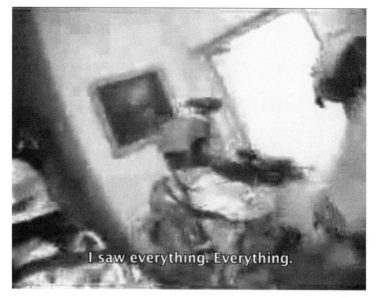

Fig. 1.3

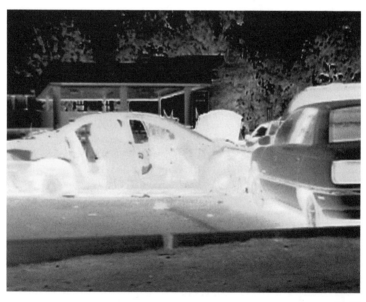

Fig. 1.4

Fig. 1.5

Fig. 1.6

Children marching, students marching. Dogs. Cats. Idlers.

Fig. 1.7

The talk briefly about their respective lives.

Fig. 1.8

Everyone's refusal. Common cowardice.

Fig. 1.9

with passages from the writer's synopsis of the film. Kolbowski's borrowings from Duras do not follow the temporal unfolding of the original script, but they nonetheless permit viewers who are unfamiliar with *Hiroshima mon amour* to grasp the outline of its story. In Kolbowski's video, text is unsynchronized with sound—in much of the shot footage there is no sound, only what the Lebanese critic and video maker Jalal Toufic calls a "diegetic silence-over," a lack of sound that reveals the immobilization of those suffering from psychic trauma.[7] The single exception is a black-and-white passage toward the end of the video which uses synchronized sound, integrating audio and visual tracks in a departure that only emphasizes the unsynchronized nature of the sound in the rest of the video.

Following the opening credits, wherein Kolbowski layers her own titles over those in Resnais's film, which appear as a kind of palimpsest (fig. 1.10), *After Hiroshima mon amour* begins with footage from the famous prologue of *Hiroshima mon amour* in which, as Duras describes it, "we see mutilated bodies . . . moving in the throes of love or death—and covered successively with the ashes, the dew, of atomic death—and

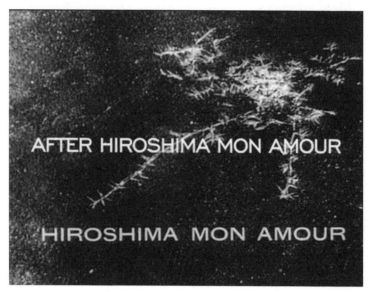

AFTER HIROSHIMA MON AMOUR

HIROSHIMA MON AMOUR

Fig. 1.10

the sweat of love fulfilled."[8] In addition to condensing the prologue—
Kolbowski's is about one minute long by contrast with the nearly fifteen-
minute original—Kolbowski altered hers in other ways (figs. 1.11, 1.12).
She sped it up by removing four frames after every fourth frame, thereby
agitating the bodies and intimating that the video will not only call at-
tention and pay homage to but also reanimate, perhaps even disturb, its
source. Kolbowski also substituted silence and written text for the male
and female voices that speak in Resnais's prologue. And whereas at
regular intervals Resnais interrupted his scenes of the bodies by cutting
to shots of the horrors of Hiroshima, which the female voice claims to
have seen, Kolbowski punctuated her opening with Internet footage
of the war in Iraq. Resnais cuts to the hospital in Hiroshima and to ex-
hibits in the Hiroshima Peace Memorial Museum: photographs of vic-
tims of the bomb, samples of metal scorched and twisted by heat,
charred stones, fallen hair, burned skin. Resnais also showed newsreels
of the aftermath of the bombing and the reconstructed city. In a spatio-
temporal displacement, Kolbowski supplanted these shots, first with
footage of American soldiers invading an Iraqi home, their shouts shat-

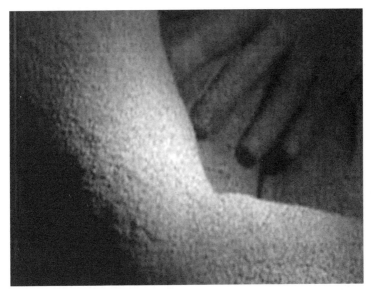

Fig. 1.11

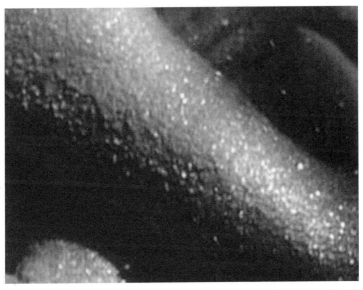

Fig. 1.12

tering the video's silence, and then with Arabic news footage of the aftermath of a bombing. Over this footage Kolbowski placed texts drawn from what Duras described as the incantatory soundtrack of Resnais's prologue, texts that refer to Hiroshima and in which the voice of the Japanese man refuses the French woman's perception and cognition, her assertions that she has seen and therefore knows the collective trauma of Hiroshima: "I saw everything. Everything"/"You saw nothing in Hiroshima. Nothing" (figs. 1.13, 1.14). In *Hiroshima mon amour* these voices are what the composer and theoretician of sound in film Michel Chion, borrowing from Pierre Schaeffer, calls acousmatic: their source is unseen.[9] In *After Hiroshima mon amour* we hear no voices, but the pronouns *I* and *you* indicate positions in a conversation, and therefore the text, like Resnais's and Duras's voices, could also be described as acousmatic: we see no originating cause of the voices that are implied. The acousmatic nature of the text is reinforced by its asynchrony with the image, since it is only if sound and image are synchronized that the source of sound can be found in the image. Chion writes that acousmatic sound draws in the spectator, creating a desire to find and initiating a questioning of its source.[10] Insofar as the soundtrack in Resnais's prologue and the text in Kolbowski's video function as a type of direct address—they speak to *you*—they strengthen this inscription of the viewer. For, as Sharon Willis observes about the opening of *Hiroshima mon amour*: "The possible addressee of "you" remains radically in question, such that, as spectators, we experience a fictive direct address that denies our very act of seeing, even as we engage in it."[11] Appropriating the film's acousmatic voices and its direct address, Kolbowski's video aligns itself with the film's ethics of representation, calling into question the viewing subject's certainty of sight and knowledge.

The images of Iraq in Kolbowski's prologue are analogous to those of Hiroshima in Resnais's film, and text about Hiroshima appears over scenes of Iraq and, later, of New Orleans (fig. 1.15). By visually substituting one historical moment and geographical site for another, Kolbowski loosens the text's reference, opening it to heterogeneous associations, and also links the bombing of Hiroshima to the Iraq War and to the abandonment of the residents of New Orleans, two moments when the United States government demonstrated a disregard for the populations of cities.

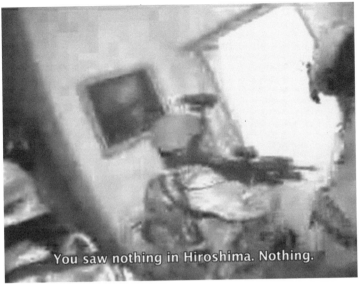

Fig. 1.13

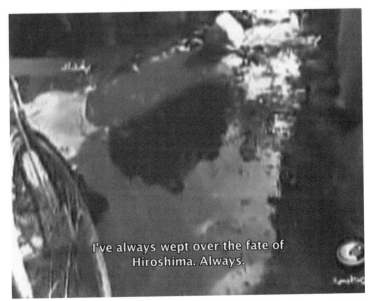

Fig. 1.14

Fig. 1.15

Kolbowski says that the invasion of Iraq precipitated her desire to re-make *Hiroshima mon amour*. Further, she relates her inspiration for the video to that of Resnais, repeating, by way of explanation, Resnais's account of what led him and Duras to make their film. According to Kolbowski, Resnais recalls that he and Duras were sitting in Duras's apart-ment. They were at an impasse about how to make a film about Hiroshima. There were, after all, plenty of good Japanese documentaries about the bombing and its aftermath. A plane flew overhead, and its sound made them realize that nothing had changed since the atomic bombs were dropped: planes were carrying bombs, the capability was still there, and the will to use them could arise again.[12] Resnais's version of the story dif-fers slightly from Kolbowski's: He and Duras were sitting in her apart-ment and heard a plane flying overhead. The sound caused him to remark on the oddness of the fact that, while planes are circling the earth carry-ing bombs, people like Duras and himself continue to lunch and go about their everyday activities. This inspired their decision to use an ordinary love story to talk about Hiroshima.[13] Kolbowski's inaccurate memory of Resnais's story—her "inadequate history" she might call it, as she does in

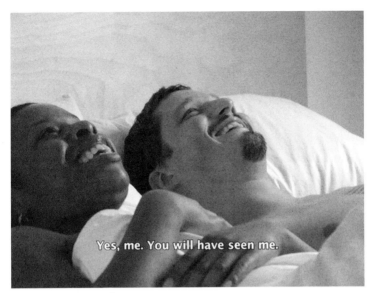

Yes, me. You will have seen me.

Fig. 1.16

an earlier work about memory[14]—accurately reveals one of her reasons for making *After Hiroshima mon amour*: the video is "after" *Hiroshima mon amour*—it repeats a film that is itself about repetition compulsion—but it is also "after" Hiroshima, an event that is not over: there is a continuity between the atomic bombing and the current situation of war.

The nature of this continuity depends of course on the significance of Hiroshima, which, as Lise Yoneyama cautions, is in no way inevitable or inherent in the event itself.[15] We know from Resnais's film that in Paris Hiroshima meant liberation while in Hiroshima it meant suffering and death. Several writers have noted that in contemporary Japan Hiroshima often signifies ideological notions of peace, which, transforming Japan into an innocent victim, suppress the memory of the country's own militarism and atrocities. The word *after* in Kolbowski's title raises the question of time and therefore of history, which is to say, of the meaning of past events. The question of time arises again when, over a black-and-white scene of the lovers in bed, a text reads, "You will have seen me" (fig. 1.16). These words, lifted from Duras's script, though excised from Resnais' film, adopt the tense of the future perfect or, in

French, the future anterior. The future anterior is used to describe an action that has not yet happened but that will have taken place before another stated occurrence or reference point in the future. The future anterior combines a subject—in our case *you*—with the verb *will have* and a past participle, which indicates a completed action or state—*seen*. In Duras's script, the words *you will have seen me* function thematically, pointing to the future of the characters in the film. But they also serve as a moment of direct address and therefore function self-reflexively: they indicate a future in which the film itself will have been seen, which is to say, the present of Kolbowski's video and of its viewer. In repeating these words, Kolbowski signals her approach to history. The future anterior is an order of time that lacks closure because in it the meaning of a past event is conditional on an inconclusive future. The past isn't simply there to be recovered; past events and actions are what will have happened as history mutates. As Jacques Lacan puts it, theorizing the future anterior as the time of personal history, "What is realized in my history is not the past definite of what was, since it is no more, or even the present perfect of what has been in what I am, but the future anterior of what I *shall have been* for what I am in the process of becoming."[16] With regard to collective history, Kolbowski's repetition of words spoken in the future anterior bespeaks an imperative to treat the dropping of the bomb on Hiroshima in terms of what it will have meant for what we as a nation or society are in the process of becoming.

The temporal structure of Kolbowski's video, which plays on that of *Hiroshima mon amour*, obeys this imperative. Both the script and the editing of Resnais's film mix temporalities: the lovers converse in past, present, future, and future anterior tenses. This shifting of tenses reflects the disintegration of narrative chronology in the traumatized psyche, just as the film's pulsating movement between remembered scenes and the present of the characters serves as a visual analogue for the time of psychic life. In this respect, it is crucial to recall Resnais's rejection of the term *flashback* to describe the reorganization of time in his films. Writing about *Je t'aime, je t'aime* (1968), he said: "I had the impression of a sort of eternal present. The hero relives his past, but when he relives it we are with him, the film always takes place in the present. There are absolutely no flashbacks or anything like them."[17] With

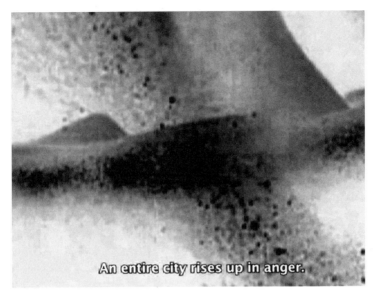

An entire city rises up in anger.

Fig. 1.17

regard to the future, Resnais was sensitive to the possibility, initiated by the nuclear age, that there might be no human future, not even, as Derrida wrote, survival in the realm of the symbolic,[18] the possibility, that is, of total destruction. Willis says that *Hiroshima mon amour* forecloses any future project,[19] a foreclosure indicated by the French woman's cry, "I'm forgetting you already," which obliterates the presence in the future of the Japanese man and of Hiroshima. In 1959, however, Eric Rohmer remarked that *"Hiroshima [mon amour]* . . . has a very strong sense of the future, particularly the anguish of the future."[20] Kolbowski shares this anguish about the film's future—which is to say, the present of *After Hiroshima mon amour*—directing her work against the forgetting that, according to Willis, the film predicts. Furthermore, Kolbowski's video makes a *wish* for the future, closing with an abstracted and color-saturated repetition of Resnais's prologue, printed in negative with its direction reversed and overlaid with a passage from Duras's script that describes cities rising up in anger against inequality (fig. 1.17). Kolbowski treats *Hiroshima mon amour* as though it were destined for the future, for *After Hiroshima mon amour* has a kind of flashforward

structure, one that suggests what Hiroshima "will have been" by substituting a movement forward from Resnais's film to the present for Resnais's movement backward from narrative present to the past. In this way Kolbowski replaces the encounter between Hiroshima and Nevers, which is staged in Resnais's film, with an encounter between Hiroshima and Iraq, two turning points in what we are in the process of becoming.

What is the meaning of the encounter? What are we becoming that calls for an admonitory return to Hiroshima? The answer is at least threefold. First, with the Iraq War and the war on terror, we are in the process of perpetuating the "American way of war" as what Mark Selden calls the "systematic slaughter of civilians from the air."[21] Kolbowski says that the bombing of Iraq in 2003 echoed the disproportionate bombing of Hiroshima, which she calls a paradigmatic change in military strategy. She recreated the look of scenes from *Hiroshima mon amour* in order to "maintain the reference to the cataclysm precipitated by the U.S."[22] It is of course true that Hiroshima marked a qualitative change in the destructiveness of weapons—indeed unleashed the possibility of total destruction—but it also continued a military change initiated earlier in World War II: terror bombing with what became known after Hiroshima and Nagasaki as conventional weapons, a term that makes them seem benign by contrast with their nuclear counterparts, when, in fact, especially with the use of depleted-uranium weaponry in Iraq, the distinction between the two is growing less clear. Hiroshima was the climax of a discourse, carried forward in the invasion of Iraq, that attributes national security to air power, a discourse whose principles were laid out in a 1942 book by Alexander P. De Seversky, *Victory Through Air Power*. Caren Kaplan points out that these principles now dominate U.S. military strategies,[23] particularly the strategy of "shock and awe," the philosophy of which was explicitly drawn from the use of nuclear weapons in Hiroshima and Nagasaki[24] and in which stress is placed on psychological effect—on, that is, psychic coercion designed to shock populations into withdrawing support from enemy governments. The spectacular attack on Hiroshima, then, will have been a precedent for the spectacular aerial bombing over Baghdad.

Second, with the conduct of the Iraq War and, even more, the war on terror—with the Bush doctrine of preemptive self-defense, and the

Bush administration's abusive interrogations and denial of legal protections for detainees at Guantanamo and Abu Ghraib, and with the policy of rendition and other threats to democratic rights that continue under President Obama—the U.S. has been in the process of exempting itself from the obligation to obey the laws of armed conflict or international humanitarian law. This, too, links Iraq with Hiroshima, for the 1949 Geneva Conventions and the additional protocols of 1977 tightened the language of the law against attacking civilian targets partly to prevent the recurrence of indiscriminate terror bombing, like that of cities in Japan during World War II. Because they were responsible for strengthening the conventions, the bombings of Hiroshima and Nagasaki stand for, even as they broke, international humanitarian law, many of whose norms, including the right of the United Nations Security Council to maintain peace, were suspended by the U.S. in the wake of September 11, 2001. It remains to be seen whether, with a new administration, the U.S. government's release of itself from the obligation to obey humanitarian law will have been an anomaly.[25]

Finally, and most important for my purposes, we are in the process of perpetuating what Hanna Segal called a "nuclear-mentality culture," a way of life that, precipitated by Hiroshima, is based on fears of annihilation and increasingly psychotic modes of defense.[26] In the 1990s, Segal argued that the nuclear-mentality culture survived the end of the cold war, persisting in the rhetoric surrounding the first Gulf War and, we can now add, in that surrounding the Iraq War: both invasions were conducted in the name of nuclear threat; Iraq was purportedly building the bomb. For Segal, Hiroshima meant the introduction of a new element in the social problem of destructiveness. The existence of atomic weapons actualized the world of the schizophrenic in which boundaries between reality and fantasy are obliterated. With the bomb, fantasies of omnipotent destruction became real.[27] Segal drew on Melanie Klein's ideas about infantile mechanisms of splitting and projection, the early ego's paranoid relation to objects, and the major role of aggression in mental life. For Klein, the infant's rudimentary ego experiences conflict between loving and destructive impulses. It rids itself of its fear of the destructiveness within by projecting danger outward, splitting in fantasy its external world into good and bad objects. In relation to its bad

objects, the infant suffers persecutory anxiety, which it denies through fantasies of omnipotence that annihilate the persecutory object. Klein said that the constant fluctuation between fear of internal and external dangers, which are experienced in light of each other, persists throughout life.[28]

Segal argued that the conflicts of individual psychology are expressed, even heightened, in group behavior.[29] As we have seen, Freud believed that the individual as a member of a national group is more likely than the individual alone to regress to behavior characteristic of early stages of development, stages characterized not only by the existence of destructive impulses but, as Klein postulated, by persecutory fears and defenses, such as projective processes. In positing the relevance of psychoanalytic insights to group dynamics, Segal followed Freud, who countered the assumption that psychoanalysis deals only with individuals by pointing out that, because individual mental life depends on relations with others, there can be no bright line between individual and group psychology.[30] After World War II, as we shall see in the next chapter, several analysts of the Kleinian school turned attention to group dynamics, which, as Segal and others point out, is often influenced by regression to psychotic phenomena: "Groups typically deal with destructiveness by splitting, the group itself being idealized and held together by brotherly love, and collective love of an ideal, while destructiveness is directed outwards to other groups."[31] Because group behavior is "very often very irrational," we should assume, said Segal, "that powerful unconscious forces are at work."[32] Nuclear rhetoric is an example: rather than face its own destructive impulses, the nation continuously projects aggression outside itself and simultaneously conquers that aggression in triumphalist fantasies. Lifton and Mitchell point out, for instance, that in the buildup to the Gulf War nuclear fear was used to justify the intervention and then, as the war drew near, the language of the first Bush administration grew increasingly triumphalist.[33] Defense Secretary Dick Cheney stated that the United States would not use nuclear weapons "at this point," but agreed in an interview that Truman had "made the right decision when he used the bomb on Hiroshima," a historical allusion that, as James Hershberg has pointed out, was meant to send a message of nuclear threat to Hussein.[34] In the years since Segal

wrote about war, the nuclear mentality she theorized has become entangled with the rhetoric of terrorist threat, which, like nuclear rhetoric, endlessly projects the source of annihilating violence outside the nation. Terrorism, says Slavoj Žižek, using a Lacanian term, has become "a quilting point" for multiple threats,[35] a universalized signifier that, like nuclear rhetoric, unites—quilts together—manifold terrors, including internal ones, that are thereby disavowed.

Segal tied the social problem of destructiveness—of, that is, war—to the will to preserve identity. Defending against anxiety, we project onto others the aggression we fear in ourselves, a mechanism that in the national group, as in the individual ego, both produces paranoia and allows the group to believe in its own virtue. Jacqueline Rose, exploring the history of Zionism, has likewise addressed the connection between destructiveness and the will to identity, arguing that belief in an autonomous national, racial, or religious identity—a belief that disavows what Naoki Sakai calls the co-figurations that constitute imagined unities such as "Japan" or "the Japanese people"[36]—leads to war. "To be a law (race, faith) unto yourself is a myth," writes Rose, a statement that Kolbowski chose as an epigraph for one of her published texts about *After Hiroshima mon amour*.[37]

The quotation is apt, for *After Hiroshima mon amour* challenges the myth of pure identity—individual, racial, ethnic, and national. In so doing, it builds on its precursor text in which the Japanese man and French woman are not only individuals but also stand for collectivities, a status underlined in the film's famous closing lines: "Hi-ro-shi-ma. That's your name/That's my name. Yes. Your name is Nevers. Ne-vers in France." Perhaps the uneasy relation between the characters' position as, on the one hand, individuals and, on the other hand, groups helps account for their difficulties with love, for, as Fornari writes, the possibility of love between individuals contrasts with the necessity of hate between groups, because "hate toward a common enemy is the group's form of love,"[38] which helps explain why group psychology disposes us toward war.

"Are you completely Japanese or not?" asks the woman in Resnais's film, a question that Kolbowski repeats in *After Hiroshima mon amour*. "Completely. I am Japanese," the man responds (figs.1.18, 1.19, 1.20). But his looks contradict his claim to purity, for the actor who played the

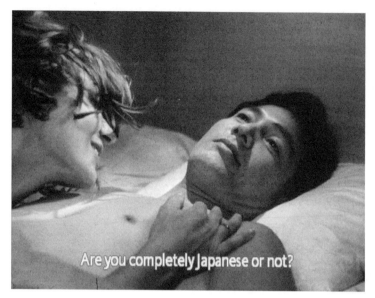

Fig. 1.18

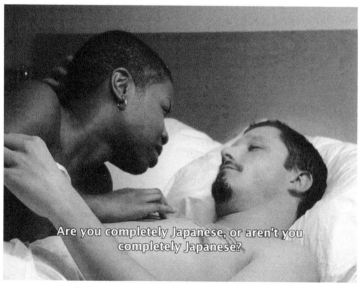

Fig. 1.19

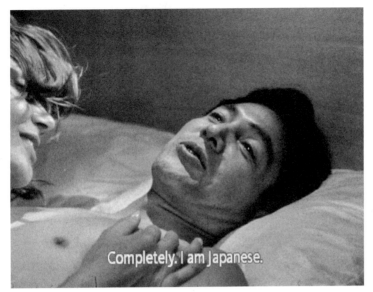

Completely. I am Japanese.

Fig. 1.20

man was chosen partly for his Western appearance. Duras stipulated that he should look Western to avoid "the involuntary racism inherent in any exoticism."[39] Whether *Hiroshima mon amour* avoids racism is a matter of debate, but there is a play with identity in Resnais's film, a play that unsettles the binary logic of nationalism and racism and that Kolbowski elaborates and renders considerably more fluid in what is perhaps the most striking feature of *After Hiroshima Mon amour*—its casting of nine actors of differing and largely indeterminate ethnicities in the roles of Duras and Resnais's French woman and Japanese man. In the opening sequence of the video, the couple consists of a man whose race cannot be specified and a black woman. Later the actors include a man who is vaguely Arabic, two Asian-looking women, and a Caucasian woman who in one scene has dark hair and in another blonde (fig. 1.21). Kolbowski disturbs the purity of races, ethnicities, and nationalities in *After Hiroshima mon amour* to warn against the role that such identity categories

Fig. 1.18. *Hiroshima mon amour*, 1959, still from black-and-white film, dir. Alain Resnais, script Marguerite Duras.
Fig. 1.20. *Hiroshima mon amour*, 1959, still from black-and-white film, dir. Alain Resnais, script Marguerite Duras.

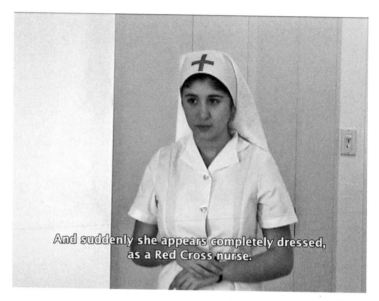

And suddenly she appears completely dressed, as a Red Cross nurse.

Fig. 1.21

play in the waging of war, relating her goals to those of Resnais and Duras: "I think Duras intends that love story to be about what war does to those who do not follow the nationalistic, ethnicist precepts of its justification."[40] Given that her subject matter is Hiroshima, a climactic moment in the history of bombing, Kolbowski's focus on race is fitting. For, as Sven Lindqvist argues, racism was a catalyst for the desire to bomb.[41] The bombings of World War II grew out of the imperialist racial killings of the earlier twentieth century, when bombing was deployed against resistance in Europe's colonies. Italy mounted the first air attack in 1911 as an act of revenge against what it considered traitorous Arabs in Tripoli. After that, bombs were dropped on civilian areas of Morocco, Somaliland, Afghanistan, Egypt, India, and Iraq by the British, Italians, Spanish, and French before European cities were bombed and before bombing became central to military thinking. As the races, nationalities, and ethnicities in Kolbowski's video proliferate so that the couple forfeits any central identity, as the asymmetry between actors and characters compounds the asynchronies between text and image and sound and image, identity is struck with doubt—

including that of the viewer, for the multiplicity and uncertainty of the characters' identities do not just produce an effect at the level of thematic content; they also block spectatorial identification and disidentification, which work to fix identity. Or, one could say, they promote less rigid projections and identifications. Insofar as Kolbowski's video raises questions about individuals as members of ethnicities, races, and nations, it broaches the topic of war's relation to group psychology, a topic that will play a major role in my interpretation of the work I'll discuss in the next chapter, Leslie Thornton's *Let Me Count the Ways*.

two • leslie thornton

Leslie Thornton released the first section of her video *Let Me Count the Ways*, titled *Minus 10*, in 2004, one year after the invasion of Iraq. Since then she has added four segments, each named, like the first segment, after the time unit of a countdown: *Minus 9*, *Minus 8*, *Minus 7*, and, the latest, *Minus 6*, which was completed in 2008. I shall focus my discussion on the first two segments, *Minus 10* and *Minus 9*.

Thornton calls *Let Me Count the Ways* an ongoing series, distinguishing it from a work in progress, the more familiar term for an unfinished work, a term that implies both imperfection and future completion. Mary Ann Doane writes that Thornton refuses to acknowledge the traditional notion of the boundary or frame constituted by the finished work, "reveling instead in the interminability of process."[1] "The important thing," says Thornton," is not to see value only in finished and exchangeable objects."[2] Thornton thus aligns her activity with that of a performing artist whose product is inseparable from the act of producing. In addition, as with Kolbowski's use of the future anterior, the incompletion of *Let Me Count the Ways* gives evidence of Thornton's approach to history: the meaning of the past, in this case, the dropping of

the atomic bomb on Hiroshima, is open-ended; we see it from an ongoing present.

Let Me Count the Ways combines archival imagery, original footage, and text, a process that results in an essayistic work that produces meaning through montage and editing. Before seeing anything, however, we hear a countdown: the voice of an American man prepares for a recorded interview with a Japanese-speaking woman, a survivor of the atom bomb, a *hibakusha*. Shortly after the bombs were dropped, as part of a scientific study of their effects, the United States Strategic Bombing Survey conducted a series of such interviews, which are now housed in the National Archive and from which Thornton drew her soundtrack. The Japanese voice-over continues as the visual track of *Minus 10* emerges, beginning with an old, presumably reedited, 16mm film, the kind once used for home movies. The shaky, faded footage shows a group of men taking pictures and indulging in horseplay on a hiking trip in, as a title informs us, the countryside outside Los Alamos, the New Mexican town where the first atom bombs, Little Boy and Fat Man, were made (fig. 2.1). This home movie is followed by a second, badly deteriorated one, shot on 8 mm film, in which we see members of Project Alberta, also known as Project A or the Destination Team, the group that developed the means of delivering the bombs and dropping them on their target cities. Members of Project A brought the bombs to the island of Tinian, in the west Pacific, from which the U.S. launched the atomic attacks. They also acted as official observers. In Thornton's video the men of Project A lightheartedly photograph each other as they prepare to load Little Boy onto the polished aluminum intercontinental bomber, a B-29, that will carry it over Hiroshima (fig. 2.2). During both home movies, the word *Dad* repeatedly appears and floats over one of the figures, identifying him as the artist's father, a nuclear physicist and engineer who participated in both the Manhattan Project and Project A (figs. 2.3, 2.4, 2.5).

This montage element—the autobiographical word *Dad*—performs several interrelated functions. First, it inscribes the artist and, with her, the viewer, into the scenes depicted in the home movies, putting them into the picture and therefore into the frame of the artist's investigations. In this way, *Dad* inserts subjectivity into the representation of the past and undermines our status as objective—scientific—viewers.

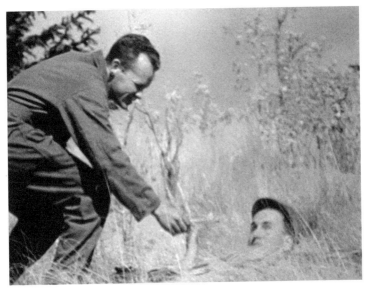

Fig. 2.1

Fig. 2.2

Leslie Thornton, *Let Me Count the Ways*, 2004–2008, stills from color video **(color)**. All images in chapter 2 are from this video.

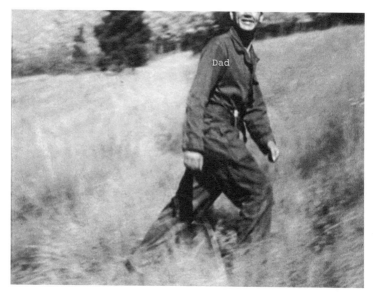

Fig. 2.3

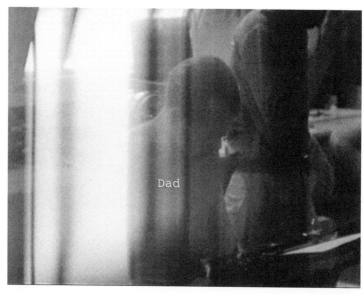

Fig. 2.4

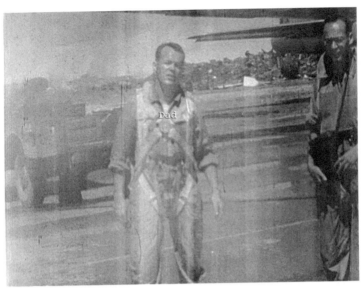

Fig. 2.5

Second, *Dad* combines personal and collective histories, breaking down any rigid opposition between the private and the public spheres. And third, *Dad* relates the nuclear-bomb-making groups pictured in the home movies to the nuclear family, which Freud considered the prototype of all groups. In her study of flashbacks in film, the cinema scholar Maureen Turim notes that in avant-garde films and videos home movie footage signifies a past—indeed, can be considered a trace of the past—and so, apart from its specific content, such footage serves as a kind of flashback, creating, like a flashback, a juncture between past and present.[3] For the men in Thornton's home movies, including Thornton's father, who is listed in the closing credits as the source of the movies, and for Thornton herself, who presumably saw the movies as a child and therefore possesses a postmemory of the events they depict, the footage constitutes a personal archive of the past. Because, however, the found footage differs from most home movies in that it depicts collective historical events and comes, like the audiotape that accompanies it, from a public archive, it combines Thornton's past with that of the nation, merging two levels of remembrance: individual

memory and wider social and political history. Like flashbacks as Turim describes them, the home movie footage in *Let Me Count the Ways* renders history as subjective experience and simultaneously casts the artist and viewer as subjects in history.[4] At the same time, the recorded voice-over of the Japanese woman, which mediates the image and bears witness to the consequences of the activities referred to in the home movies—the making, assembling, loading, and dropping of the bomb—places a hibakusha in the position of narrator of history, dividing the formation of subjectivity at the opening of the video.

In conjunction with the voice of the Japanese woman, the word *Dad* establishes a human scale against which to measure the historical catastrophe of Hiroshima. *Dad*, like the home movie format in which it appears, evokes the emphasis on domesticity that characterized the United States in the 1950s, when Thornton was a child, an emphasis that has been linked to the atomic bombings. Cultural historians Douglas T. Miller and Marion Nowak write, for example, that

the domesticity of the fifties might not have gone to such extremes if not for the way the war ended. The atom bombings of Hiroshima and Nagasaki, so resonant of Hitlerian evil, promised a long shock-filled future. These shocks did materialize, too: the immediate anti-Soviet cold war, frantic arms racing and, by 1947, Truman's introduction of the witch hunts that would soon be called McCarthyism. The American economy was being reshaped by the addiction to militarism and by the burgeoning corporations. . . . People turned . . . to . . . a mock-Victorian vision of life . . . Mom the homemaker, Dad the breadwinner, smiling determinedly in their traditional roles.[5]

Thornton disturbs the innocence of this idealized vision of American domesticity. For, like Sylvia Plath's famous poem "Daddy," in which the poet associates her father with Nazism,[6] though in a far less accusatory and phantasmatic and far more deadpan manner, *Let Me Count the Ways* juxtaposes the intimate domestic sphere—signified by *Dad*—with a historical atrocity—Hiroshima—bringing together two fields that at first seem far apart but that are in fact closely related. Miller and Nowak, as we have seen, draw a connection between the two on a

sociological level, while, from a psychoanalytic point of view, the family is the realm of transmission—the relay—between the formation of subjectivity and the broader society. Like Plath's daddy, Thornton's dad carries the weight of individual and collective memory and guilt. And, as Jacqueline Rose writes about Plath, Thornton, too, though, again, more gently, "forces the viewer to enter into something which she or he is often willing to consider only on condition of seeing it as something in which psychically no less than historically, she or he plays absolutely no part."[7]

In the case of *Let Me Count the Ways*, this disavowed something has to do with group behavior, from which no individual is immune, as no one is outside a group or innocent of group psychology. For the video's troubling proximity of cozy domesticity and historical atrocity is paralleled by an equally disturbing juxtaposition of, on the one hand, the playful conviviality of the members of the Manhattan Project and Project A groups—conduct reminiscent of the prankish attitude of the American soldiers at Abu Ghraib prison—and, on the other hand, the catastrophe these groups played a critical role in perpetrating. Merrymaking seems to have been one common mode of behavior for the groups involved in the development and dropping of the bomb. Norman Foster Ramsey, a physicist who worked on the Manhattan Project and oversaw Project A, described the atmosphere at the Enola Gay's hardstand before the plane took off for Hiroshima: It was like a Hollywood premiere, he recalled: "amid brilliant floodlights, pictures were taken and retaken by still and motion picture photographers."[8] Scientists were invited to write messages on the bomb. They accepted. Some of the messages were obscene. One Project A member wrote, "To the people of Japan, from my friends in China,"[9] a statement that regressively assumed that the bomb was being dropped on a group—the Japanese construed as a single guilty entity—rather than on an aggregate of individuals living in the city of Hiroshima. A Manhattan Project scientist later referred to what he called the whoopee spirit with which he and others received the news of the bombing, a memory that filled him with shame after John Hersey's essay on Hiroshima appeared in 1946.[10] The *Minus 10* segment of *Let Me Count the Ways* captures something of this whoopee spirit and thus returns to Hiroshima to confront our darkest,

most disillusioning truths, truths that, according to Freud, come to the fore when we bind ourselves into groups.

It is a commonplace to assert that psychoanalytic theory deals only with individuals, but in fact it has shed a great deal of light on collective behavior and therefore on war, which is, above all, a collective phenomenon. Not only does psychoanalysis treat the psychology of the individual as a function of her relationships to other persons; it also explores the psychopathology specific to group subjectivity or what Freud called the "group mind." In 1921 Freud published *Mass Psychology and the Analysis of the "I,"* a text that extends some of his wartime reflections in "Thoughts for the Times on War and Death," which I mentioned in the introduction to these essays. In *Mass Psychology* Freud once again commented on the regression that characterizes the transition from individual to group psychology: "In a group the individual is brought under conditions which allow him to throw off the repressions of his unconscious instinctual impulses. The apparently new characteristics which he then displays are in fact the manifestations of this unconscious, in which all that is evil in the human mind is contained as a predisposition."[11] And in *Civilization and Its Discontents* of 1930, in a passage that almost seems designed to account for the revelry of the bomb-making and assembling scientists in Thornton's video, Freud speculated that the satisfaction of the destructive impulses "is accompanied by an extraordinarily high degree of narcissistic enjoyment, owing to its presenting the ego with a fulfillment of the latter's old wishes for omnipotence."[12]

Groups, said Freud, citing churches and armies as examples, are held together by emotional ties that can arise from either common identification with a leader or common devotion to an abstract idea or concrete object. Perhaps even to a bomb. Such passionate identifications and devotions are expressions of the libidinal or loving impulses, which seek to preserve and unite and coexist with—on occasion, even assist—the aggressive impulses, which seek to destroy and kill. The coupling of the two is embodied in the title of Thornton's video, *Let Me Count the Ways*, which, taken from the first line of Elizabeth Barrett Browning's love poem, a poem that itself combines references to love and death, also invokes the countdown to a bombing. Indeed, in the bombing of Hiroshima, as Franco Fornari observed, a destructive reality was wrapped in

symbols of procreation and love: the bomber was named after the pilot's mother, Enola Gay, and Leslie Groves, director of the Manhattan Project, alerted President Truman that the Trinity bomb test was successful with the code phrase "Baby is born."[13] The bomb itself was dubbed Little Boy. Like the narcissistic ego, the group, too, maintains an idealized image of itself and preserves this self-love by projecting outside itself—into other groups—those qualities, such as aggressivity, that threaten its self-ideal. As Hanna Segal put it, "Freud . . . said that we can love one another in a group provided there are outsiders whom we can hate."[14]

In 1952, the British psychoanalyst Wilfred R. Bion published a highly influential essay titled "Group Dynamics" in which he elaborated Freud's idea that groups are driven by unconscious forces.[15] To supplement Freud, Bion drew on the work of Melanie Klein. Like Freud, he argued that a special capacity for regression characterizes groups, but for him, unlike for Freud, this regression leads back not to neurotic but rather to psychotic patterns of behavior. "I hope to show," wrote Bion, "that in his contact with the complexities of life in a group the adult resorts, in what may be a massive regression, to mechanisms described by Klein as typical of the earliest phases of mental life."[16] As we know from the previous chapter, these mechanisms include psychotic fantasies, anxieties, and defenses. To repeat: The early ego's ambivalence between loving and destructive impulses is experienced in relation to objects, or, rather, part objects, primarily the maternal breast, which, as Klaus Theweleit observes, stands for the principle of the outside world.[17] The infant deflects its destructive impulses outward by projecting them into external objects, originally its love object, which it splits in two; good experiences are attributed to good objects and bad experiences to bad ones, in relation to which the developing ego suffers persecutory anxieties. Klein called this early stage paranoid-schizoid because of the paranoid anxiety in relation to a bad object and the schizoid split between idealized and persecutory experiences. For Bion, the central position in group dynamics is occupied by regression to the primitive mental mechanisms peculiar to the paranoid-schizoid position. Every group, according to Bion, actually contains two groups: a "work group" and a "basic assumption group." All groups meet to do something, and a group

functions as a work group insofar as it fulfills the task that the group has come together to perform. However, work groups are pervaded by states of mind and powerful emotional drives, indeed psychotic premises, that Bion labels basic assumptions. As Segal explains it, "Our psychotic parts are merged into our group identity and we do not feel mad since our views are sanctioned by the group."[18] Whereas the work group fulfills a task, the basic assumption group acts out unconscious fantasies and defends against unconscious anxieties. One basic assumption is what Bion calls the fight-flight assumption, which is the assumption that the group has met in order to fight something or to run away from it.[19] If the work activity predominates, the group functions at a realistic level and its psychotic elements are held in check. But, says Bion, there are certain specialized work groups whose task itself is likely to stimulate the activity of a particular basic assumption, for example, the army—we could add the Manhattan Project and Project A—which, exciting both the paranoid and omnipotent fantasies of the fight-flight basic assumption, endorses a consequent release of hate, which finds an outlet in destructive attacks.[20] When the basic assumption dominates, an imagined enemy can be projected into a real enemy. We might then read the "whoopee spirit" of the Project A group in Thornton's *Minus 10* as an instance in which Bion's basic assumption of persecution and defensive omnipotence has gained ascendancy over the task-oriented Manhattan Project and Project A, a distortion that is implicit in the group's task and that renders the group subject unable to foresee correctly the consequences of its actions. And because it is also an important function of the group to shield individuals from guilt feelings by sanctioning aggressive impulses, we could also understand the behavior of the members of the Manhattan Project and Project A, as Rose understands the behavior of U.S. troops at Abu Ghraib, as an attempt to erase the group's discomfort.[21]

At the end of *Minus 10*, the home movie of Project A gives way to seemingly unrelated footage of another group: an audience of American sailors and soldiers, some taking pictures, watches a female Asian dancer (fig. 2.6). A superimposed title connects this scene to the earlier ones, informing us that, after delivering the bomb to Tinian Island, Thornton's father was among the group of scientists who watched from

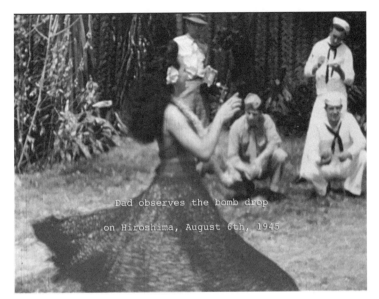

Dad observes the bomb drop
on Hiroshima, August 6th, 1945

Fig. 2.6

an accompanying airplane as the *Enola Gay*'s bombardier released the bomb: "August 6, 1945, 8:15 A.M./Dad observes the bomb drop on Hiroshima." The image shows a female Asian body made to connote sexual and racial otherness as well as exoticism and spectacle, so that Orientalism is aligned with scopophilia, or pleasure in looking, which Freud counted among the sexual drives.[22] Under the influence of the title, the look of the sailors watching the Asian dancer—and the photographic look—is tied to the look of the father watching the bombing of the Asian city, hinting at the sexualized mania that often pervades war violence. And, conversely, under the influence of the image, the purportedly neutral, scientific look of the title is invested with desire. Because the scientists' airborne vision is affiliated with the acts of sighting and taking aim at a bombing target, both looks are implicated in the annihilation of their objects. The closing scene of *Minus 10* thus forms a bridge between the video's opening section and its next segment, *Minus 9*, in which Thornton draws a relationship between vision, especially photographic vision, and the violence of war.

For Paul Virilio, who has explored the way in which cameras form part of the equipment of war, this relationship constitutes the significance of Hiroshima, a significance that, added to those I discussed in the previous chapter, links Hiroshima to contemporary techno-warfare: the blinding flash of the atomic bomb—what the Japanese call the *pikadon*, a brilliant light followed by a thunderous blast—represented, according to Virilio, the complete merger of observation and destruction.[23] For this reason, the atomic bombings, which were made possible by aerial photography of the bomb's targets and whose effects were photographed from accompanying planes, was a climactic moment in the history of what Virilio calls a developing "war of light." A "watching machine," says Virilio, has always existed alongside the war machine. The watchtower, the anchored balloon, the reconnaissance aircraft, and remote-sensing satellites—these devices, whose existence required the military to call upon scientists, have long given the eye "the function of a weapon."[24] The war of light, however, in which the enemy is illuminated as it is killed, only began in the twentieth century, in, to be precise, 1904, when, during the Russo-Japanese war, a searchlight was used for the first time. By 1914, antiaircraft artillery had combined guns with searchlights. These light-weapons, says Virilio, did not just illuminate battlefields; they shed light on a future in which perception and destruction would become coterminous.[25] Hiroshima was that future. I quote at length from Virilio's description of the manner in which the nuclear flash impressed the shadow of objects onto the surfaces of human bodies and of the city:

many epilogues have been written about the nuclear explosions of 6 and 9 August 1945, but few have pointed out that the bombs dropped on Hiroshima and Nagasaki were *light-weapons* that prefigured the enhanced-radiation neutron bomb, the directed-beam laser weapons, and the charged-particle guns currently under development. . . . The first bomb produced a nuclear flash which lasted one fifteen-millionth of a second, and whose brightness penetrated every building down to the cellars. It left its imprint on stone walls. . . . The same was the case with clothing and bodies, where kimono patterns were tattooed on the victims' flesh. If photography, according to its inventor Nicéphore Niepce, was simply a method of engraving

with light, where bodies inscribed their traces by virtue of their own luminosity, nuclear weapons inherited the darkroom of Niepce and Daguerre and the military searchlight. What appears in the heart of darkrooms is no longer a luminous outline but a shadow, one which sometimes, as in Hiroshima, is carried to the depths of cellars and vaults. The Japanese shadows are inscribed not, as in former times, on the screens of a shadow puppet theatre but on a new screen, the walls of the city.[26]

Like Virilio, Akira Mizuta Lippit, a scholar of cinema and Japanese culture, has added to the meanings of Hiroshima by linking the event to light. In his book *Atomic Light (Shadow Optics)*, Lippit argues that, in addition to unleashing the potential for total destruction, a destruction that would extinguish the possibility of even symbolic survival, the light of the atomic bomb inaugurated a crisis of visuality, of, that is, social and historical sight. First, the detonated bomb initiated an "excess visuality," a catastrophic light, which, in conjunction with nuclear heat, annihilated the bodies it touched, reducing them to ashes.[27] Elaborating on Virilio, Lippit, too, says that "atomic irradiation can be seen as having created a type of violent photography directly onto the surfaces of the human body. The catastrophic flashes followed by a dense darkness transformed Hiroshima and Nagasaki into photographic laboratories, leaving countless traces of photographic and skiagraphic imprints on the landscape, on organic and nonorganic bodies alike."[28] Lippit argues further that the excess visuality introduced by the atomic bombs initiated a new mode of visuality, which he calls avisuality and which, he says, characterizes the postatomic world: what is seen in this world is the absence caused by the excess visuality produced by the bomb.[29] Avisuality is a visuality that, paradoxically, shows nothing, a visuality in which, as Lippit puts it, the unseen appears.[30] There is a sense of the visual but no image. Hence, "you saw nothing in Hiroshima." Avisuality is akin to what Jalal Toufic refers to as the "withdrawal of tradition past a surpassing disaster."[31] A surpassing disaster, says Toufic, is a catastrophic political event that destabilizes a culture's relationship to its history. After a surpassing disaster, tradition is withdrawn and unavailable to vision. For Toufic, *Hiroshima mon amour* stresses this unavailability. When the Japanese man in the film insists that the French woman has "seen nothing in Hiroshima,"

his words do not just question the possibility of seeing and knowing trauma or the West's ability to understand the disaster inflicted on a non-Western group, as other commentators have suggested. Rather, these words include the woman as a member of what Toufic terms the community of the surpassing disaster, for whom "nothing" is precisely what is seen—an objective nothing: the catastrophic loss that is the withdrawal of tradition after a surpassing disaster.[32]

"There can be no authentic photography of atomic war," writes Lippit, "because the bombings were themselves a form of total photography that exceeded the economies of representation."[33] Which is to say that only symbols can represent atomic warfare, symbols that bear witness to the avisuality, that is, the unrepresentability, of the catastrophe. The most common displaced referent for the obliterating force of atomic weaponry is of course the so-called mushroom cloud, which became the quintessential image both of a dangerous technology and, ironically, of the promise of science—"We lost to the enemy's science," a Japanese newspaper declared barely two weeks after the bombing.[34] Blanchot described the mushroom cloud as a public image of the death drive.[35] Thornton, however, forgoes the clichéd image, which has been criticized for its depoliticizing organicism, and, in keeping with Virilio's and Lippit's depictions of the atomic bombs as light-weapons, she substitutes found footage of, first, a flashbulb going off, which serves as an emblem of the *pikadon,* and, then, of a self-developing Polaroid camera, which figures the bomb's immediate effects (figs. 2.7, 2.8). The Polaroid camera is a fitting symbol not only because, like the bomb, it produced instant photographs but also because the invention of the Polaroid in 1948 was greeted, like that of the atomic bomb in 1945, as a technological "miracle," a kind of scientific "magic," as the voice-over of *Minus 9* describes the bomb. Interestingly, with regard to the "technological fanaticism" that, according to Michael Sherry, shaped the American air war and to the relationship between war and technologies of perception,[36] at the moment the bomb was dropped the military and scientific teams onboard the *Enola Gay* bomber donned Polaroid goggles to protect their eyes from the flash.

Whereas the *Minus 10* segment of *Let Me Count the Ways* portrays preparations for the atomic bombing, *Minus 9* represents the bombing

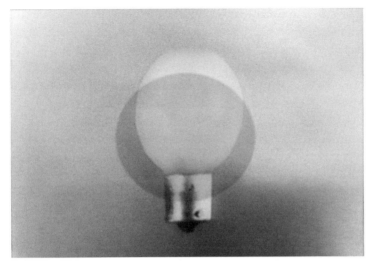

Fig. 2.7

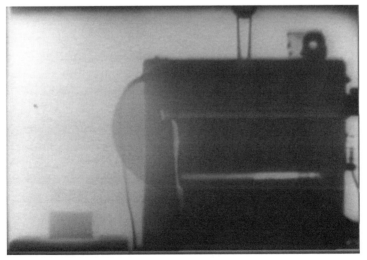

Fig. 2.8

itself and its immediate effects, just as *Minus 8* and *Minus 7*, which deal with mutations in irradiated plants, might be read as an allegory of the bomb's longer-term effects, what Kenzaburo Oe describes as the "haunting question of genetics."[37] Like *Minus 10*, *Minus 9* begins with a black screen and a voice-over of a 1945 interview with a Hiroshima survivor. This time the speaker is, as the closing credits inform us, a Miss Palchikoff, who provided the only English-language eyewitness account of the bombing in the National Archive.[38] The visual track of *Minus 9* consists of an assemblage of cityscapes shot by the artist. These are mixed with found historical footage—obtained from the archive—showing various technological devices used in war—tanks, a jet engine, and cameras—as well as scenes of Operation Hardtack, a series of nuclear tests conducted by the United States in 1958 (figs. 2.9, 2.10, 2.11, 2.12). Most of the footage is faint and is mediated not only by the soundtrack but by heavy pixilation and an internal rectangular frame, which makes it seem as though we are looking through the viewfinder of a camera or perhaps a bombsight. In addition, a bright blue disk continually pulses in front of the scenes, further obscuring our view of the historical imagery. The pulsing disk is like an afterimage, the glow that seems to float before one's eyes after staring at a bright light, such as a flash or the sun, to which the atomic flash is routinely compared (fig. 2.13). This symbol is multidetermined. The disk also resembles, for example, Cherenkov radiation, the characteristic blue glow that surrounds the core of a nuclear reactor, and witnesses often describe the atomic flash as "bluish." The artist refers to the pulsing blue dot as also "a numbing device, almost trance-triggering, inducing a physiologically passive reception of the faint, ghosted imagery over which it is superimposed." It serves "as a physiological metaphor for memory, whether personal or historical, which involves a kind of glazing over, and in this case, exhaustion."[39] At the same time, at least insofar as it can be read as an afterimage, the blue dot suggests that, despite the vicissitudes of memory, the vision of America's action in Hiroshima persists; like an afterimage, its consequences are inescapable.

Meanwhile, as *Minus 9* unfolds, Miss Palchikoff gives an account of the effects of the atomic bombing that is inconsistent in at least one important respect. Asked by the interviewer whether white people suf-

Plate 1

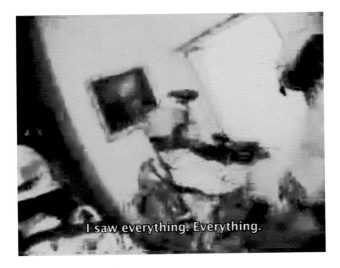

I saw everything. Everything.

Plate 2

Plates 1–12: Silvia Kolbowski, *After Hiroshima mon amour,* 2005–2008, stills from black-and-white and color video.

Plate 3

Plate 4

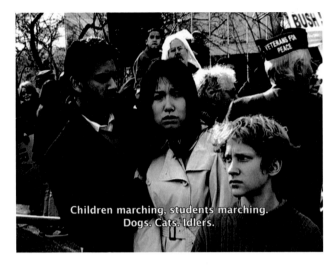

Children marching, students marching.
Dogs. Cats. Idlers.

Plate 5

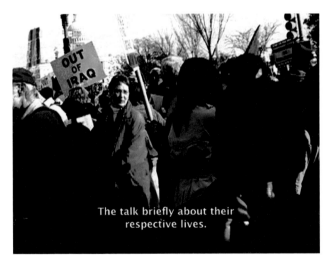

The talk briefly about their
respective lives.

Plate 6

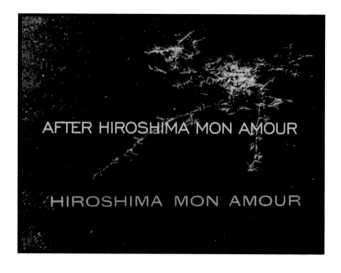

Plate 7

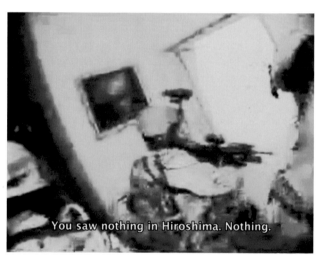

Plate 8

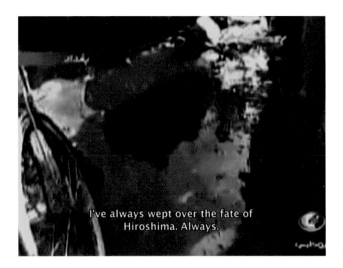

Plate 9

Plate 10

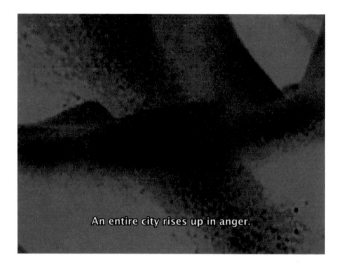

Plate 11

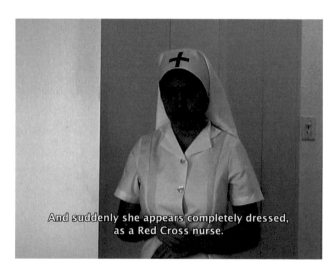

Plate 12

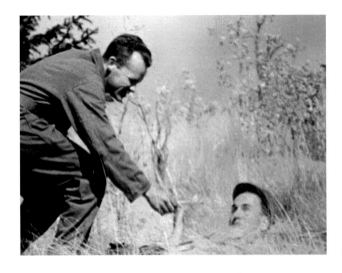

Plate 13

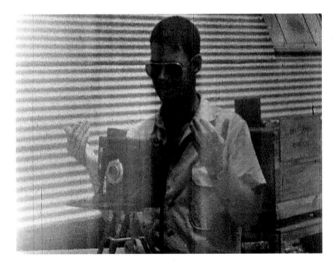

Plate 14

Plates 13–27: Leslie Thornton, *Let Me Count the Ways*, 2004–2008, stills from color video.

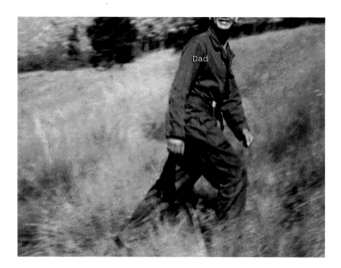

Plate 15

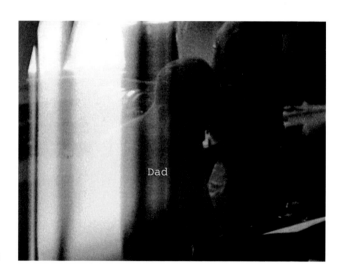

Plate 16

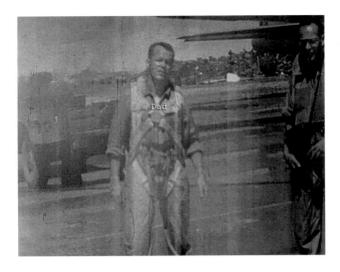

Plate 17

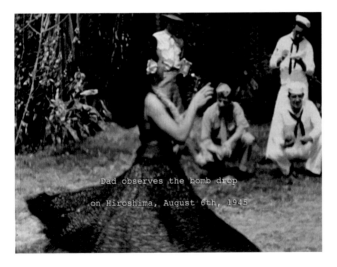

Plate 18

Plate 19

Plate 20

Plate 21

Plate 22

Plate 23

Plate 24

Plate 25

Plate 26

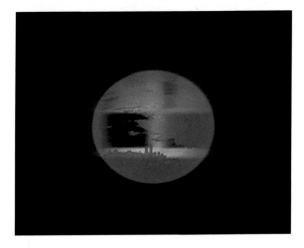

Plate 27

Plate 28

Plates 28–31: Krzysztof Wodiczko, *The Hiroshima Projection*, 1999, stills from color video.

Plate 29

Plate 30

Plate 31

Fig. 2.9

Fig. 2.10

Fig. 2.11

Fig. 2.12

Fig. 2.13

fered any burns, she emphatically replies, "No. Not one white person was burned. They were injured but not burned." Soon after, however, she insists that not only did no white people lose their hair but that "not a single white person was injured in any way." Testifying that white people were unaffected by the nuclear flash and atomic radiation, she voices a fantasy about the invincibility of the Western body, even as her contradictory statements attest to an underlying insecurity about that body's fragility. Directly following this portion of the narration, the visual track of *Let Me Count the Ways* causes Miss Palchikoff's discourse of Western invulnerability to falter: in an aerial shot of New York City taken before September 11, 2001, we see a tiny World Trade Center, the very buildings whose fate challenges such a triumphalist discourse (figs. 2.14, 2.15). With this shot, Thornton links the terror bombing of Hiroshima to the terrorist attacks on the twin towers, attacks that indeed generated a level of energy that has been compared to nuclear blasts. The architecture theorist Mark Wigley, analyzing the unconscious association we draw between buildings and bodies, the way we use buildings to construct an image of what we would like the body to be—of,

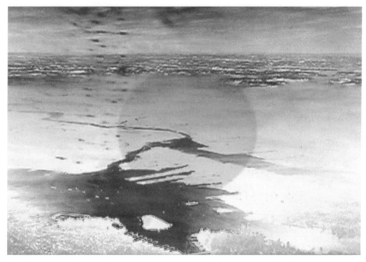

Fig. 2.14

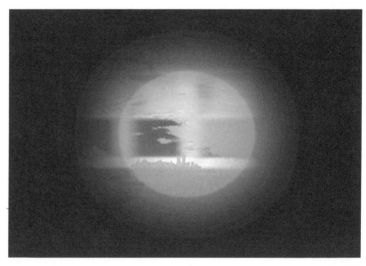

Fig. 2.15

that is, ideal, invulnerable bodies—describes the spectacle of September 11 in words that recall the atomic bombing:

Buildings and bodies were instantly compacted into an extraordinarily dense pile or dispersed to the wind. Many of the occupants were instantly "rendered into dust," as the medical examiner's office put it. The resulting cloud blanketed the bottom of the island and was blown to all corners of the city. . . . The bodies themselves were mainly lost, and even the number of victims stayed a mystery. . . . The watching world became endlessly captivated by the twisted and pulverized remains of the structures.[40]

As in Miss Palchikoff's description of the bombing of Hiroshima, the vulnerability exposed by the World Trade Center attacks has been collectively denied not only, as Wigley argues, by plans for rebuilding, in which architects mobilize images of security, but also by the subsequent launching of the war on terror and, especially, the Iraq War, with which, like Miss Palchikoff, the Bush administration sought to bury trauma by taking refuge in triumphalism, in, that is, heroic masculinism or what Freud identified as a defensive fantasy of omnipotence.

"War is a security organization," wrote Franco Fornari, author of *The Psychoanalysis of War* and member of Psychoanalysts for the Prevention of Nuclear War.[41] He did not mean that war protects us from real enemies. Rather, referring to the phantasmatic dimension of war, Fornari argued that war is mobilized to protect us against deep-seated anxieties—anxieties about destructiveness and persecution—by projecting internal terrors outward into real or imagined enemies, a mechanism that allows us to hate without guilt and that mobilizes defense. War has visible and invisible functions, said Fornari. The visible function corresponds to the defense against real external danger, while the more important, hidden function—the rest of the proverbial iceberg— "corresponds to an unconscious security maneuver against terrifying fantasy entities," which Fornari labels the Internal Terrifier. War is a security system "not because it permits us to defend ourselves from external enemies but because it succeeds in finding real enemies to kill."[42] The manic triumphalism that followed in the wake of September 11 and that was manifested in the invasion of Iraq would seem to

provide a textbook example of the way in which a historical reality can mobilize unconscious anxieties to destructive ends. In a period when the rhetoric of terrorist threat, like that of nuclear threat, with which it is often combined, endlessly locates the sources of violence outside the nation, in a historical moment when security has become a self-evident virtue and heroic masculinism endangers the world, it seems urgent not only to confront our own dark truths, as I have been arguing so far, but to take another step and foster an ethics of vulnerability, as does Krzysztof Wodiczko's *Hiroshima Projection*, the work I'll discuss in the next chapter.

three • krzysztof wodiczko

In some ways, Krzysztof Wodiczko's *Hiroshima Projection* is an anomaly among the group of artworks that I've chosen to discuss in these essays. For one thing, unlike Kolbowski's *After Hiroshima mon amour* and Thornton's *Let Me Count the Ways*, Wodiczko's video was made before the Iraq War, though after the first Gulf War, to which it refers. For another, while the video is a work in its own right, it also documents one of the artist's outdoor projections (figs. 3.1, 3.2, 3.3, 3.4). In these public works, Wodiczko projects images—in the case of the *Hiroshima Projection*, moving images—onto the surfaces of existing architectural and urban structures, revealing, often subverting, these structures' social functions. The *Hiroshima Projection* took place in the city of Hiroshima on the nights of August 7 and 8, 1999, the two days following the anniversary of the dropping of the atomic bomb. In preparation for the projection Wodiczko spoke with a variety of city residents: Japanese survivors of the bomb, who had to face not only the bombing and the radiation but also the official justification for the American attack; Korean *choyoko* or forced laborers, who were victims both of the bomb and of Japanese imperialism and discrimination; and

Fig. 3.1

Krzysztof Wodiczko, *The Hiroshima Projection*, 1999, stills from color video. All images in chapter 3 are from this video.

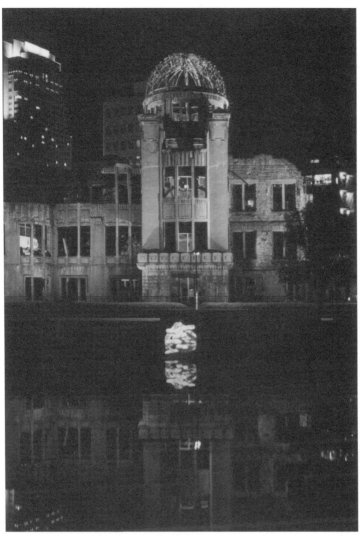

Fig. 3.2

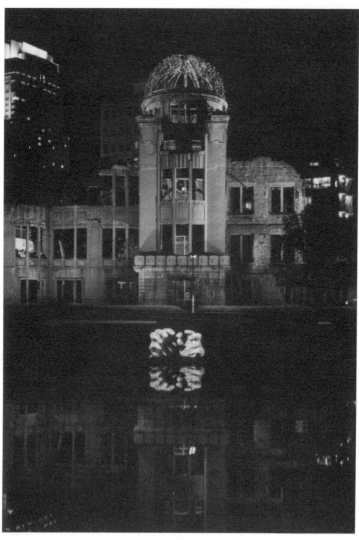

Fig. 3.3

descendents of survivors, second- and third-generation victims of the bomb. As the witnesses talked about the bombing and about present-day Hiroshima, the artist recorded their testimonies and also videotaped their hands. During the projection, loudspeakers played audiotapes of the testimonies as enlarged, synchronized images of the speakers' moving, gesturing hands materialized on the embankment of the portion of the Motoyasu River flowing directly beneath the city's Atomic Dome. Reflections of the projected hands appeared on the surface of the water, which had reached its highest point during the hours of the projection. In 1945, when the bomb exploded over the dome, thousands of badly burned residents threw themselves into the river to ease their pain, but the water was irradiated and soon filled with corpses. The dome, however, survived and, regarded as a witness to the trauma, has since been left in its ruined state, as a memorial. As one of the speakers in *The Hiroshima Projection* puts it, "The Dome is watching for eternity." At night the Dome is bathed in light, an illumination that dates from 1989, when it formed part of an urban renewal plan to make Hiroshima "brighter" and "more cheerful."[1] Wodiczko's projection, which played three times on each night it was performed, lasted about forty minutes and consisted of fifteen testimonies, nine of which are recorded in the twenty-minute video. Over the two nights of the performance, an audience of more than four thousand people gathered on the opposite side of the river. The projection anthropomorphized the dome, whose "body" seemed to be the source of the voices and thus became a speaking rather than a mute witness to trauma.

Many writers have noted the silence of the victims in the years following the dropping of the bomb. In her book *Hiroshima Traces*, a study of Hiroshima memory, Lise Yoneyama notes that the difficulties faced by survivors in talking about their experiences cannot be overestimated: "after nearly half a century no more than a small scattering of the over 370,000 survivors who witnessed the Hiroshima and Nagasaki nuclear atrocities have openly voiced their survival memories."[2] Before the American victors established their presence in defeated Japan, the country's imperial government censored the media and, beginning in mid-September 1945, the occupying authorities refused to allow public discussion of the bombs.[3] After official censorship was lifted in 1949,

testimonies began to emerge, especially after the 1954 U.S. hydrogen bomb test at the Bikini atoll, but these testimonies became discursively constrained by what Yoneyama calls, following Michel Foucault, regimes of truth production—national and legal procedures, medical and psychiatric investigations, scholarly research, and the depoliticized peace movement, all of which have structured and ritualized first-person accounts of the atomic disaster, determining what will and will not constitute truth.[4] Testimonies have frequently been met with suspicion and ambivalence, and this has led to what Monica Braw refers to as the "voluntary silence."[5] As we learn from Rie Tsujino's account of her aborted hopes of marriage in the *Hiroshima Projection*, a situation that is also central to Masuji Ibuse's classic Hiroshima novel *Black Rain*, there are still social prejudices against hibakusha and nisei, the second generation, especially of women, who, born on the site of the atomic bomb, often feel stigmatized by the belief that they represent a genetic threat to society. In addition, speaking, which means taking up a position that is distanced from events spoken about, is sometimes viewed as a betrayal of those who died, a fear echoing that of the French woman in *Hiroshima mon amour*. Some worry that talking about the bombing will harm the city's image. In recent years, criticism of testimonial practices has come from another end of the political spectrum: some leftists have asserted that hibakusha, by narrating their victimization, have become part of what Ian Buruma somewhat callously calls the pacifist cult of Hiroshima, a nationalist system that perpetuates the Japanese government's repression of memories of Japan's own aggression before and during the war.[6] And yet, as the historian John W. Dower points out, individuals and grassroots movements have actually struggled to reshape official memory of the war, and, what is more, "the fixation on Japan's nuclear victimization proved unexpectedly subversive—for the closer the Japanese looked at Hiroshima and Nagasaki, the clearer it became that more nationalities than just the Japanese had been killed there."[7] Twenty to thirty thousand Koreans also died, and, with regard to them, the Japanese were not victims but, rather, victimizers; as *The Hiroshima Projection* makes clear, and as nationalistic memories conceal, Korean survivors faced discrimination with regard to rescue, medical treatment, and burial: "Those frightening heat-rays burnt iron and rocks,"

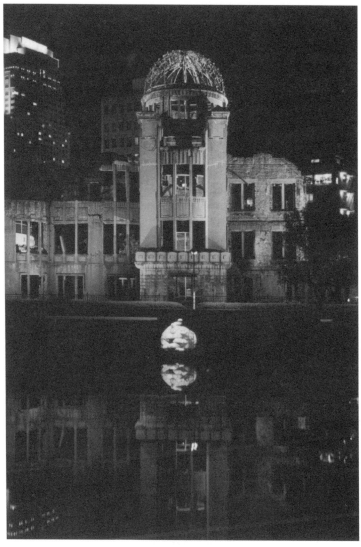

Fig. 3.4

says seventy-year-old Lee Sil Gun, "and when the whole city was burnt and burnt to ashes, one thing did not burn—discrimination . . . discrimination stays alive even today."

The Hiroshima Projection simultaneously contributed to and intervened in Hiroshima testimonial practices. Providing a new framework for public speech—a work of visual art—Wodiczko lent support to those survivors who, beginning in the 1980s, have tried to resist recuperation by nationalist memorial narratives and who, in the words of Matsuda Go, a hibakusha quoted by Yoneyama, have not wanted their listeners "to learn only about the atom bomb" but "about the conditions of war more generally."[8] Since at least 1938, when Virginia Woolf published her classic antiwar text *Three Guineas*, which, connecting the psychic and the political, attributes war to masculinist grandiosity and egotism, feminists have insisted that the conditions that lead to war include triumphalist fantasies, as I have been contending throughout these essays. Wodiczko's *Hiroshima Projection*, I now want to argue, brings the feminist challenge to such fantasies into the public sphere and into debates about the meaning of the public sphere. Traditional critical conceptions of the public sphere, as I have written elsewhere, are themselves triumphalist insofar as they posit a public subject that, emerging from privacy, exercises a totalizing, which is to say, a mastering, vision of society.[9] By contrast, Wodiczko's work stages a scene of address that fosters the emergence of a public sphere in which the viewing subject is asked to respond to what Emmanuel Levinas calls the face-of-the-other and, in so doing, to renounce the will to mastery.

A good place to start exploring this thesis is Hannah Arendt's famous definition of the democratic public sphere as "the space of appearance," of, that is, what phenomenology calls coming into view. In stressing appearance, Arendt connected the public sphere, which she modeled on the Greek polis, to the field of vision and unintentionally opened up the possibility that visual art might play a role in deepening and extending democracy, a possibility that, throughout his career, Wodiczko has attempted to realize. In 1958 Arendt wrote:

The *polis* . . . is not the city-state in its physical location; it is the organization of the people as it arises out of acting and speaking together, and its

true space lies between people living together for this purpose, no matter where they happen to be. . . . It is the space of appearance in the widest sense of the word, namely, the space where I appear to others as others appear to me, where men . . . make their appearance explicitly.[10]

Later political philosophers have also connected public space to appearance. Jacques Rancière, for one, defines both democratic practice and radical aesthetics as the disruption of the system of divisions and boundaries that determines which social groups are visible and audible and which invisible and inaudible.[11] Earlier, in the 1980s, the French political philosopher Claude Lefort, influenced by but wanting to historicize Arendt, tied the ability to appear in public space to the declaration of rights. For Lefort, the hallmark of democracy is uncertainty about the foundations of social life. The democratic revolutions of the eighteenth century, says Lefort, and the French and American declarations of rights shifted the location of power. The power of the state was no longer attributed to a transcendent source, such as God, natural law, or self-evident Truth. Now power derived from "the people." Yet, with the disappearance of references to a transcendent source of power, an unconditional source of social unity—of the meaning of the people— vanished as well. The people were now the source of power, but they had no fixed identity. "Democracy," says Lefort, "is instituted and sustained by the dissolution of the markers of certainty. It inaugurates a history in which people experience a fundamental indeterminacy as to the basis of power, law and knowledge, as to the basis of relations between self and other."[12] The meaning of society becomes a question, a question that is decided within society but is not immanent there. Rather, democracy gives rise to public space, a realm of political interaction, which appears, when, in the absence of a proper ground, the meaning and unity of the social order is at once constituted and put at risk. Precisely because the social order is uncertain, it is open to contestation, so what is recognized in public space is the legitimacy of debate about what is legitimate and what is illegitimate. Debate is initiated with the declaration of rights, but the democratic invention deprives rights, just as it has the people, of a solid foundation. Rights, too, become an enigma. Their source is not God or nature but the human utterance of

right and the social interaction implicit in the act of declaring. Through this interaction, those who hold no position in the political community make an appearance as, in the act of declaring new specific rights, they repeat the original democratic demand for freedom and equality. Thus they also declare what Etienne Balibar calls a universal right to politics,[13] which, following Lefort, can be regarded as a right to appear as a speaking subject in the public sphere. On this account, the space of appearance—the public sphere—itself appears when social groups declare the right to appear.

Latent in Arendt's and Lefort's notion of the public sphere as the space of appearance is the ethico-political question not of how we appear but of how we respond to the appearance of others. To be public is to be exposed to alterity. Consequently, artists who want to deepen and extend the public sphere have a twofold task: creating works that help those who have been rendered invisible to "make their appearance" and developing viewers' capacity for public life by asking them to respond to, rather than react against, that appearance.

At this point, however, a problem arises—a contradiction between the two tasks—for important strands of contemporary art—in particular, feminist critiques of representation—have analyzed vision as precisely the sense that, instead of welcoming others, tends to meet them in relations of conquest, to make them disappear as other. Transforming the other into a distanced image or bounded entity set before the self, vision, it has been argued, is a vehicle of the human subject's desire for mastery and self-possession. Oriented toward triumphalism rather than response, vision can, for example, take the form of a negative hallucination in which we fail to see something that is present but unknowable, something whose presence we don't want to know about. If, then, exposure to others lies at the heart of democratic public life, the question of what art can offer in a situation of war, of how in a period of war it can help develop the capacity for being in public, calls for still others: With what kind of vision shall we meet the appearance of others? Can art help establish ways of seeing that do not seek to reduce the impact of exposure? What kind of vision might overcome apathy and respond to the suffering of others? In short, what is public vision?

Here, I think, the philosopher Emmanuel Levinas can help us, for his reevaluation of ethics offers a way of thinking about visuality and the space of appearances that challenges triumphalist vision. Levinas is not preoccupied with the appearance of the self—of the "I." In fact, he asks, "Is there not something like a war present in this affirmation of the self?" Rather, he is concerned with the way "I" call myself into question when exposed to the appearance of the other, an other who, for him, is not an object of comprehension but, rather, an enigma. Levinas calls the other person who appears to me the face, but the face—or, as he also names it, the neighbor—is more than the other person in the world: it is a manifestation of the Other in the sense of that which cannot be made fully visible or knowable. The Other approaches but cannot be reduced to a content; the Other appears but cannot be fully seen. More, when the other appears, it is accompanied by something else, something Levinas calls the third party. The approach of the third party is not, like that of the face, an empirical event. It is the emergence of an awareness that, as Colin Davis puts it, "the Other is never simply *my* other." Rather, "the Other implies the possibility of others, for whom I am myself an Other. . . . I am made to realize that the Other does not exist merely for my sake, that my neighbor is also a neighbor to the third party, and indeed that to them it is I who am the third party."[14]

With the notion of the third party, Levinas enters the discourse of the public sphere, for the third party lifts the encounter with the other beyond the space of a dyadic meeting and sets it down in public space. The third party is the "whole of humanity that looks at me," and the relation with the face, insofar as it is also always a relation with the third party, "places itself in the full light of the public order."[15] The other's approach, or appearance, bespeaks the social world, but tells me that I cannot meet that world from a position of full understanding, which would make it "mine." The world does not belong to me. Levinas writes, "the presence of the other is equivalent to this calling into question of my joyous possession of the world."[16]

Levinas's face dispossesses the subject of knowledge, and this dispossession recalls the dissolution of certainty that for Lefort gives rise to public space. In these ways Lefort and Levinas are philosophers of the enigma—of that which escapes comprehension and dismantles

self-possession, if we understand self-possession as a sense of being undisturbed by the presence of anything one does not know and cannot control. The inhabitant of the Lefortian or Levinsian public sphere does not aspire to total knowledge of the social world, as in traditional theories of the public sphere, for such knowledge positions the subject outside social space—on another planet, as Iris Marion Young puts it—and, endowing society with a substantive foundation that totalizes it, eliminates otherness.[17] As Arendt said, such knowledge exchanges "the real world for an imaginary one where . . . others would simply not exist."[18] By contrast, the disappearance of certainty that in Lefort's and Levinas's accounts calls us into public space obliges us to be what Levinas calls non-indifferent to the appearance of the other. "Non-indifference" is an ability to respond to the other, a "response-ability" that Levinas considers the essence of the reasonable being in man. Levinas's idea of responsibility is part of an ethico-political discourse that differs from traditional meditations on morality. Instead of beginning with the universality of some rational moral law, Levinas, as he summarizes it, "takes off from the idea that ethics arises in the relation to the other."[19] While morality is a discourse of certainty, ethics is incompatible with moral certainty, for responsiveness to the face-of-the-other disrupts narcissism; it interferes with idealizations of the self as a being able to comprehend the whole. What is more—and with this we come back to the space of appearance—Levinas links the question of ethical response to the question of vision or, more particularly, to a *critique* of vision. "Ethics is an optics," he writes. "But," he continues, "it is a 'vision' *without image*, bereft of the synoptic and totalizing, objectifying virtues of vision, a relation . . . of a wholly different type."[20] On this account, the appearance of the other, which brings public space into existence, is not a perceptual event but rather one that calls for a different kind of vision.

To encourage the appearance of the public sphere of appearances is, then, to promote "vision without image" or nonindifferent ways of seeing. And since nonindifferent vision obliges us to call ourselves into question, artists who explore its possibilities take part in the psychic, subjective transformation, which, like material transformation, is an essential component—and no mere epiphenomenon—of social change.

Furthering nonindifference, however, is not simply a matter of making visible those social groups that have been rendered invisible in the existing public spheres or of making true images of others to counteract false ones. For, as we have seen, Levinas's face-of-the-other is precisely that which is lost when caught as an image. Images, Levinas warns, transform faces into "figures which are visible but de-faced."[21]

We have, then, arrived at a final problem: How can art aid the appearance of others while at the same time making visible the limits the face places on representation, limits that are the message of the face? Wodiczko's *Hiroshima Projection* represents one solution, though at first it may seem odd to mention the face in connection with a work that shows no faces and, what is more, draws attention to its failure to do so. Yet the lack of faces in Wodiczko's work is precisely the point, for, as we have seen, Levinas's face is not the literal face but precisely that which eludes the grasp of knowledge and vision. In appearing, the face surpasses what can be "seen." Rather, says Levinas, "the face speaks,"[22] as do the invisible faces in the *Hiroshima Projection*. The face exceeds vision insofar as vision is, again in Levinas's words, a "search for adequation," a search, that is, to fully know and master the object of knowledge.[23] Indeed, the face cries out for *in*adequate vision, which is to say, response.

Insisting on inadequate vision, the *Hiroshima Projection* belongs within a feminist practice of contemporary art that produces what have been called critical images, images that undo the viewing subject's narcissistic fantasies, fantasies that blind us to otherness, either rejecting it or assimilating it to the knowing ego or the Same.[24] Critical images interrupt self-absorption, promoting answerability to the other, establishing nonindifferent modes of seeing, and thereby developing the experience of being in public. This seems especially urgent in a time of war for, as Judith Butler writes in her 2004 essay "Precarious Life," which deals with war and representation, Levinas's face is one of the casualties of war. The task of cultural criticism, according to Butler—what it can offer in the present situation of war—is to return us to the face, to, that is, the human, a return that demands a critique of representation, for it is in the field of representation that humanization and dehumanization occur. To illustrate her point, Butler contrasts Levinas's conception of the

face with the dominant American media's representation of literal Arab faces. The media presents these faces in both humanizing and dehumanizing ways. The dehumanized faces of Osama bin Laden, Yasser Arafat, and Saddam Hussein, says Butler, have been deployed to encourage disidentification with the Arab world. At the same time, the unveiled faces of young Afghan women no longer wearing the *burka* humanize the war, but in a manner that symbolizes the successful importation of American culture. Presented as either *"the spoils of war or . . . the targets of war,"* faces like these, marshaled in the service of war, silence the suffering over war.[25] Butler calls them "triumphalist images," not only because American triumph is their thematic content or subtext but because they disavow the failure—which is to say, the inadequacy—of representation. As a consequence, triumphalist images blot out the appearance of the face.

By contrast, critical images trouble the visual field, promoting nonindifferent vision and contributing to the transformation not only of the blind eye but also of the deaf ear. Wodiczko's *Hiroshima Projection* increases this transformative potential by engaging viewers in a kind of seeing—and listening—known as witnessing, an act that is crucial in our time of collective, human-inflicted, traumas, such as war and torture, that call out for witnesses. Giorgio Agamben has theorized the position of the witness as the basis of ethico-political subjectivity because, he says, the witness responds to the suffering of others without taking the place of the other.[26] Agamben is indebted, as are all theorists of witnessing, to Primo Levi, who, writing about his survival of Auschwitz, described witnessing in terms that are similar to what Levinas calls being-for-the-other. A friend once told Levi that he—Levi—was saved for a reason—to bear witness. The comment horrified Levi because it implicitly denigrated those who were not saved, those who, as he put it, "drowned." To challenge this implication, Levi insisted that the survivor of the Nazi concentration camp is not a true or complete witness, since he did not undergo the full experience of the camps, which was an experience of death. Levi said: "We, the survivors, are not the true witnesses" because survivors didn't "touch bottom": The destruction brought to an end, the job completed, was not told by anyone."[27] The survivor witness, then, is only a "witness by proxy." Since

the true witness cannot speak, Levi positioned himself, a survivor, as a secondary rather than primary witness, ceding his place to the other without claiming to speak for the dead. In the *Hiroshima Projection* the hibakusha Kwak Bok Soon does the same. "People who died, died without speaking [a word]," she says, "I survived and am alive, on their behalf, so I must dare to talk without feeling embarrassed about hating it."

Witnessing is a way of seeing and listening that requires an acceptance of inadequacy, a renunciation, as I said earlier, of the will to mastery, for, as Cathy Caruth has argued, to bear witness to the truth of suffering over a traumatic event, such as the Hiroshima bombing, is to bear witness to that event's incomprehensibility for its victims.[28] Taking as her starting point Freud's observation that trauma victims are compelled to repeat the event that caused psychic trauma, Caruth adds that repetition is not only the victim's attempt to prepare herself retroactively for the event, as Freud speculated; repetition is also a cry for the suffering to be witnessed. "The history of a trauma can only take place through the listening of another," writes Caruth.[29] But, since by definition the event that caused the trauma was so overwhelming that it could not be fully known or experienced at the time it occurred, the victim suffers from incomprehension, and, if the witness claims to understand the experience, he claims to understand too much, and so betrays the victim. This poses a problem for aesthetic representations that want to respond to the suffering of others, for while traumatic suffering calls out for the event to be witnessed, it creates a need for a new kind of witnessing—what Caruth calls the witnessing of an impossibility, the impossibility of comprehending the trauma.[30] Witnessing in the ethical sense of responding thus necessitates a critique of images based on notions of representational adequacy.

The Hiroshima Projection mounts such a critique. Wodiczko has called it a work of memorial therapy, a term with at least two meanings. It refers to therapy for troubled societies conducted through memorials. And it refers to therapy for memorials, structures such as Hiroshima's Atomic Dome, which in its silent, ruined condition resembles a person silenced by historical trauma and by indifference, a person like Kwak Bok Soon, who was unable to speak when confronted with the U.S. State Department official who, repeating the official American

narrative about Hiroshima, refused to bear witness. "The official," she recalled,

started discussing the theory of nuclear deterrence. I could tolerate his theory up to a certain point. But he said something at the end. He said the dropping of the bomb was absolutely not wrong. He said that it was thanks to that the war could be ended earlier and at least the lives of 200,000 soldiers were saved. . . . I felt so spiteful toward the official . . . "Excuse me? Who do you think you're saying this to? . . . People who suffered because of the bomb have come to talk to you eagerly about wanting to save the Earth, when they could instead be blaming you for the lives you impaired. And to bring up the theory of nuclear deterrence on top of that . . . who are you saying this to?" I felt that way, at that time. And I didn't have the words to protest to him then . . . in fact, I couldn't say a single word.

Transforming the Atomic Dome into a living body, Wodiczko's projection gave the traumatized building the status of a speaking subject. Summoning it out of its mute condition, which has been partially imposed by its role as official witness, Wodiczko talked with it, like a psychotherapist. The projection also helped the human victims speak by highlighting the supplemental language of their gesturing hands—the language of the unconscious mind—while withdrawing their faces. This withdrawal protected the speakers from the grasp of vision with image, vision that knows too much. In this way, the projection facilitated the appearance of the face and asked—even obligated—viewers to take up the position of witnesses whose inadequate vision permits them to respond to suffering. Showing how representation fails in the presence of the face-of-the-other, the *Hiroshima Projection* also facilitated the emergence of a public sphere in which the appearance of others is prized because, questioning the social order, it keeps democracy from disappearing. This activity is crucial at a historical moment when the rhetoric of security, which justifies both continuous war and the suspension of democratic politics, is still threatening to engulf us.

notes

Introduction

1. Blanchot, The Writing of the Disaster, p. 78.
2. "Questionnaire," p. 9.
3. Ibid., p. 10.
4. Ibid., pp. 9–10.
5. Buchloh and Churner, "Introduction," p. 5.
6. See Deutsche, "Not Forgetting," pp. 26–37.
7. Brown, "Resisting Left Melancholy," pp. 458–465.
8. Ibid., pp. 462–463.
9. Freud, "Thoughts for the Times on War and Death," p. 280.
10. Sherry, The Rise of American Air Power, p. 14.
11. Freud, "Thoughts for the Times on War and Death," p. 285.
12. Ibid., p. 279.
13. Ibid., p. 296.
14. Brown, "Resisting Left Melancholy," p. 460.
15. Quoted in Lifton and Mitchell, Hiroshima in America, p. 175.
16. Leung, "Response to Questionnaire," pp. 123, 102.
17. Segal, "From Hiroshima to the Gulf War and After," pp. 167–168.
18. Bion, Experiences in Groups and Other Papers, p. 22.
19. Money-Kyrle, "A Psychological Analysis of the Causes of War" (1934), p. 132.

20. Rose, "Freud and the People," pp. 166–167.

21. Fornari, The Psychoanalysis of War, pp. xxv–xxvi.

1. Silvia Kolbowski

1. Lifton and Mitchell, *Hiroshima in America*, p. 356.

2. Kennan, *The Nuclear Delusion*, pp. 177–178, quoted in Lifton and Mitchell, *Hiroshima in America*, p. 356.

3. Ginsberg, "America," p. 39.

4. Lifton and Mitchell, *Hiroshima in America*, p. 222.

5. For an account of the controversy over this exhibition see Hogan, "The Enola Gay Controversy," pp. 200–232.

6. Deleuze, *Cinema 1*, p. 118.

7. "Jalal Toufic: An Interview by Kaelen Wilson-Goldie," in Jerrold Shiroma, ed., *Towards a Foreign Likeness Bent: Translation* (Duration, 2005), p. 91.

8. Duras, "Synopsis," in *Hiroshima Mon Amour*, p. 8.

9. Chion, *Audio-Vision*.

10. Ibid.

11. Willis, *Marguerite Duras*, p. 39.

12. Kolbowski, "After *Hiroshima Mon Amour*," p. 81.

13. Alain Resnais video interview, directed by François Chalais for *Cinepanorama*, aired October 7, 1961. In Criterion Collection DVD of *Hiroshima mon amour*.

14. For accounts of Kolbowski's *an inadequate history of conceptual art* (1998–1999), see Deutsche, "Inadequacy"; and Nixon, "Oral Histories," in *Silvia Kolbowski: inadequate . . . Like . . . Power*, Vienna, The Secession, 2004, pp. 67–80, pp. 93–102.

15. Yoneyama, *Hiroshima Traces*, p. 39.

16. Lacan, "The Function and Field of Speech and Language in Psychoanalysis," p. 86.

17. Turim, *Flashbacks in Film*, p. 220.

18. Derrida, "No Apocalypse," pp. 20–31.

19. Willis, *Marguerite Duras*, p. 51.

20. Rohmer, "*Hiroshima mon amour*, pp. 59–70.

21. Selden, "A Forgotten Holocaust," p. 87.

22. Kolbowski, "After *Hiroshima Mon Amour*," p. 82.

23. Kaplan, "Mobility and War," pp. 395–407.

24. Young, "Bombing Civilians," p. 171.

25. Gutman, Rieff, and Dworkin, "Preface to the Second Edition," p. 11.

26. Segal, "From Hiroshima to the Gulf War," p. 166.

27. Ibid., pp. 163–164.

28. Klein, "Notes on Some Schizoid Mechanisms" (1946) and "On the Theory of Anxiety and Guilt" (1948).

29. Segal, "From Hiroshima to the Gulf War and After," pp. 162–163.

30. Freud, *Group Psychology and the Analysis of the Ego*, p. 3.

31. Segal, "From Hiroshima to the Gulf War and After," p. 161.

32. Ibid., p. 160.

33. Lifton and Mitchell, *Hiroshima in America*, p. 221.

34. Quoted in ibid.

35. Žižek, "Are We in a War?"

36. Sakai, *Translation and Subjectivity*.

37. Rose, *The Question of Zion*, p. 81, quoted in Kolbowski, "Before *After Hiroshima Mon Amour*," pp. 11–26.

38. Fornari, *The Psychoanalysis of War*, p. 175.

39. Duras, "Portrait of the Japanese," in *Hiroshima Mon Amour*, p. 109.

40. Kolbowski, "After *Hiroshima Mon Amour*," p. 84.

41. Lindqvist, *A History of Bombing*.

2. Leslie Thornton

1. Doane, "A Brief Overview of the Work of Leslie Thornton."

2. Borger, "An Interview with Leslie Thornton."

3. Turim, "Childhood Memories and Household Events," p. 246.

4. Turim, *Flashbacks in Film*, p. 2.

5. Miller and Nowak, *The Fifties*, p. 152.

6. Plath, "Daddy," pp. 222–224.

7. Rose, *The Haunting of Sylvia Plath*, p. 236.

8. Quoted in Rhodes, *The Making of the Atomic Bomb*, p. 704.

9. Johnston, "Adventures at Wartime Los Alamos."

10. Lifton and Mitchell, *Hiroshima in America*, p. 88.

11. Freud, *Group Psychology and the Analysis of the Ego* (1921), p. 9.

12. Freud, *Civilization and its Discontents* (1930), p. 76.

13. Fornari, *The Psychoanalysis of War*, p. ix.

14. Segal, "Silence Is the Real Crime," p. 147.

15. Bion, "Group Dynamics," pp. 141–191.

16. Ibid., p. 141.

17. Theweleit, *Male Fantasies*, p. 211.

18. Segal, "From Hiroshima to the Gulf War," p. 162.

19. Bion, "Group Dynamics," p. 152.

20. Ibid., p. 156.

21. Rose, "Freud and the People," p. 167.

22. Mary Ann Doane notes the same alignment in Thornton's 1983 film, *Adynata*. See Doane, *Femmes Fatales*, p. 180.

23. Virilio, *War and Cinema*, p. 81.

24. Ibid., p. 3.

25. Ibid, p. 68.

26. Ibid., pp. 80–81.

27. Lippit, *Atomic Light*, p. 4.

28. Ibid., p. 109.

29. Ibid., p. 32.

30. Ibid., p. 84.

31. Toufic, "Forthcoming," pp. 46–75.

32. Ibid., p. 73.

33. Lippit, *Atomic Light*, p. 95.

34. Dower, "The Bombed," p. 121.

35. Blanchot, *The Writing of the Disaster*, p. 119.

36. Sherry, "The United States and Strategic Bombing," p. 178.

37. Oe, *Hiroshima Notes*, p. 75.

38. http://soundportraits.org/on-air/witness_to_the_atom_bomb/.

39. E-mail correspondence with the artist, September 12, 2009.

40. Wigley, "Insecurity by Design," p. 73.

41. Fornari, *The Psychoanalysis of War*, p. xvi.

42. Ibid.

3. Krzysztof Wodiczko

1. Yoneyama, *Hiroshima Traces*, p. 51.

2. Ibid., p. 89.

3. Dower, "The Bombed," pp. 116–118.

4. Ibid., pp. 32, 93–94.

5. Braw, "Hiroshima and Nagasaki," pp. 155–172.

6. Buruma, *The Wages of Guilt*, p. 101.

7. Dower, "The Bombed," p. 139.

8. Yoneyama, *Hiroshima Traces*, p. 124.

9. See Deutsche, "Agoraphobia," pp. 269–327.

10. Arendt, *The Human Condition*, pp. 198–199.

11. Rancière, *The Politics of Aesthetics*.

12. Lefort, "The Question of Democracy," p. 19.

13. Balibar, " 'Rights of Man,' " p. 49.

14. Davis, *Levinas*, p. 83.

15. Levinas, *Totality and Infinity*.

16. Ibid, pp. 75–76.

17. For critiques of such accounts of the public sphere, see Young, "Impartiality and the Civic Public," pp. 57–76; Fraser, "Rethinking the Public Sphere," pp. 109–142; Robbins, "Introduction," in *The Phantom Public Sphere*; Thomas Keenan, "Windows: Of Vulnerability," in Robbins, *The Phantom Public Sphere*, pp. 121–141; and Deutsche, "Agoraphobia."

18. Arendt, *The Human Condition*, p. 234.

19. Levinas, "Being-for-the-Other," p. 114.

20. Ibid., p. 23.

21. Ibid., p. 116.

22. Levinas, "The Face," p. 87.

23. Ibid.

24. For accounts of the feminist critique of visual representation, see Owens, "The Discourse of Others," pp. 166–190; and Deutsche, "Boys Town" and "Agoraphobia."

25. Butler, "Precarious Life," p. 143.

26. Agamben, *Remnants of Auschwitz*.

27. Levi, *The Drowned and the Saved*, pp. 83–84.

28. Caruth, "Recapturing the Past," p. 153

29. Caruth, "Trauma and Experience: Introduction," p. 11.

30. Ibid., p. 10.

bibliography

Agamben, Giorgio. *Remnants of Auschwitz: The Witness and the Archive*. Trans. Daniel Heller-Roazen. New York: Zone, 1999.

Arendt, Hannah. *The Human Condition*. Chicago: University of Chicago Press, 1958.

Balibar, Etienne. "'Rights of Man' and 'Rights of the Citizen:' The Modern Dialectic of Equality and Freedom." In *Masses, Classes, Ideas: Studies on Politics and Philosophy Before and After Marx*, pp. 39–59. Trans. James Swenson. New York: Routledge, 1994.

Bion, W. R., *Experiences in Groups and Other Papers*. New York: Routledge, 1961.

Blanchot, Maurice. *The Writing of the Disaster*. Trans. Ann Smock. Lincoln: University of Nebraska Press, 1986.

Borger, Irene. "An Interview with Leslie Thornton." In Rolando Caputo and Scott Murray, eds., *Senses of Cinema*, September 2002, http://archive.sensesofcinema.com/contents/02/22/ thornton_interview.html; originally published in *The Force of Curiosity*, ed. with interviews by Irene Borger. Santa Monica: CalArts/Alpert Award in the Arts, 1999.

Braw, Monica. "Hiroshima and Nagasaki: The Voluntary Silence." In Laura Hein and Mark Selden, eds., *Living with the Bomb: American and Japanese Cultural Conflicts in the Nuclear Age*, pp. 155–172. Armonk, NY: Sharpe, 1997.

Brown, Wendy. "Resisting Left Melancholy." In David L. Eng and David Kazanjian, eds., *Loss*, pp. 458–465. Berkeley: University of California Press, 2003.

Buchloh, Benjamin, and Rachel Churner. "Introduction." *October* 123 (Winter 2008): 3–8.

Buruma, Ian. *The Wages of Guilt: Memories of War in Germany and Japan.* New York: Meridian, 1994.

Butler, Judith, "Precarious Life." In *Precarious Life: The Powers of Mourning and Violence,* pp. 128–151. London: Verso, 2004.

Caruth, Cathy. "Literature and the Enactment of Memory (Duras, Resnais, *Hiroshima mon amour*)." In *Unclaimed Experience: Trauma, Narrative, and History,* pp. 25–56. Baltimore: Johns Hopkins University Press, 1996.

Caruth, Cathy, ed., "Trauma and Experience" and "Recapturing the Past." In *Trauma: Explorations in Memory,* pp. 1–12 and 149–157. Baltimore: Johns Hopkins University Press, 1995.

Chion, Michel. *Audio-Vision: Sound on Screen.* Trans. Claudia Gorbman. New York: Columbia University Press, 1994.

Davis, Colin. *Levinas: An Introduction.* Notre Dame: University of Notre Dame Press, 1996.

Deluze, Gilles. *Cinema 1: The Movement-Image.* Trans. Hugh Tomlinson and Barbara Habberjam. Minneapolis: University of Minnesota Press, 1986.

Derrida, Jacques, "No Apocalypse, Not Now (Full Speed Ahead, Seven Missiles, Seven Missives)." *Diacritics* 14, no. 2 (Summer 1984): 20–31.

Deutsche, Rosalyn. "Agoraphobia." In *Evictions: Art and Spatial Politics,* pp. 269–327. Cambridge: MIT Press, 1996.

——— "Boys Town." In *Evictions: Art and Spatial Politics,* pp. 203–244. Cambridge: MIT Press, 1996.

——— "Not-Forgetting: Mary Kelly's *Love Songs.*" *Grey Room* 24 (Summer 2006): 26–37.

Doane, Mary Ann. "A Brief Overview of the Work of Leslie Thornton." In Rolando Caputo and Scott Murray, eds., *Senses of Cinema,* September 2002, http://www.sensesofcinema.com/ contents/02/22/ thornton.html; accessed May 28, 2008.

——— *Femmes Fatales: Feminism, Film Theory, Psychoanalysis.* New York: Routledge, 1991.

Domarchi, Jean, Jacques Donoil-Valcroze, Jean-Luc Godard, Pierre Kast, Jacques Rivette, and Eric Rohmer. "*Hiroshima notre amour.*" In Jim Hillier, ed., *Cahiers du Cinéma: The 1950s, Neo-Realism, Hollywood, New Wave,* pp. 59–70. Cambridge: Harvard University Press, 1985.

Dower, John W. "The Bombed: Hiroshimas and Nagasakis in Japanese Memory." In Michael Hogan, ed., *Hiroshima in History and Memory,* pp. 116–142. Cambridge: Cambridge University Press, 1996.

Duras, Marguerite. "Portrait of the Japanese." In *Hiroshima Mon Amour,* pp. 109–110. Trans. Richard Seaver. New York: Grove, 1961.

——— "Synopsis." In *Hiroshima Mon Amour,* pp. 8–13. Trans. Richard Seaver. New York: Grove, 1961.

Fornari, Franco. *The Psychoanalysis of War.* Garden City, NY: Anchor, 1974.

Fraser, Nancy. "Rethinking the Public Sphere: A Contribution to the Critique of Actually Existing Democracy." In Craig Calhoun, ed., *Habermas and the Public Sphere*, pp. 109–142. Cambridge: MIT Press, 1992.

Freud, Sigmund. *Civilization and Its Discontents*. Ed. and trans. James Strachey, New York: Norton, 1961.

—— *Group Psychology and the Analysis of the Ego*. Ed. and trans. James Strachey, New York: Norton, 1959.

—— "Thoughts for the Times on War and Death." In *The Standard Edition of the Complete Psychological Works of Sigmund Freud* 14:275–300. Ed. and trans. James Strachey. London: Hogarth, 1953–1974.

—— "Why War?" In *The Standard Edition of the Complete Psychological Works of Sigmund Freud* 22:195–215. Ed. and trans. James Strachey. London: Hogarth, 1953–1974.

Ginsberg, Allen. "America." In *Howl and Other Poems*, pp. 39–43. San Francisco: City Lights, 1956.

Gutman, Roy, David Rieff, and Anthony Dworkin. "Preface to the Second Edition." In *Crimes of War: What the Public Should Know*, pp. 8–11. Rev. ed. New York: Norton, 2007.

Hogan, Michael J. "The Enola Gay Controversy: History, Memory, and the Politics of Presentation." In Michael J. Hogan, ed., *Hiroshima in History and Memory*, pp. 200–232. Cambridge: Cambridge University Press, 1996.

Johnston, Lawrence. "Adventures at Wartime Los Alamos." Talk presented as part of the Heritage Lecture Series at the Los Alamos National Laboratory. Los Alamos, New Mexico, August 9, 2006.

Kaplan, Caren. "Mobility and War: The Cosmic View of U.S. 'Air Power.'" *Environment and Planning A* 38 (2007): 395–407.

Klein, Melanie. "Notes on Some Schizoid Mechanisms." In *Envy and Gratitude and Other Works: 1946–1963*, vol. 3: *The Writings of Melanie Klein*, pp. 1–24. Ed. Roger Money-Kyrle. New York: Free Press, 1975.

—— "On the Theory of Anxiety and Guilt." In *Envy and Gratitude and Other Works: 1946–1963*, vol 3: *The Writings of Melanie Klein*, pp. 25–42. Ed. Roger Money-Kyrle. New York: Free Press, 1975.

Kolbowski, Silvia. "After *Hiroshima Mon Amour*." *Art Journal* 66, no. 3 (Fall 2007): 80–84.

—— . "Before *After Hiroshima Mon Amour*." *Farimani* 1, no. 1 (March 2008): 11–26.

Lacan, Jacques. "The Function and Field of Speech and Language in Psychoanalysis." In *Écrits: A Selection*, pp. 30–113. Trans. Alan Sheridan. New York: Norton, 1977.

Lefort, Claude. "The Question of Democracy." In *Democracy and Political Theory*, pp. 9–20. Trans. David Macey. Minneapolis: University of Minnesota Press, 1988.

Leung, Simon. "Response to Questionnaire." *October* 123 (Winter 2008): 102–104.

Levi, Primo. *The Drowned and the Saved*. Trans. Raymond Rosenthal. New York: Random House, 1989.

Levinas, Emmanuel. "Being-for-the-Other." In Jill Robbins, ed., *Is It Righteous To Be? Interviews with Emmanuel Levinas*, pp. 114–120. Stanford: Stanford University Press, 2001.

—— "The Face." In *Ethics and Infinity*, pp. 83–92. Trans. Richard A. Cohen. Pittsburgh: Duquesne University Press, 1985.

—— *Totality and Infinity*. Trans. Alphonso Lingis. Pittsburgh: Duquesne University Press, 1969. Originally published as *Totaite et Infini*. The Hague: Martinus Nijhoff, 1961.

Lifton, Robert Jay, and Greg Mitchell. *Hiroshima in America: Fifty Years of Denial*. New York: G.P. Putnam's Sons, 1995.

Lindqvist, Sven. *A History of Bombing*. London: Granta, 2001.

Lippit, Akira Mizuta. *Atomic Light (Shadow Optics)*. Minneapolis: University of Minnesota Press, 2005.

Miller, Douglas T., and Marion Nowak. *The Fifties: The Way We Really Were*. Garden City, NY: Doubleday, 1975.

Money-Kyrle, Roger. "A Psychological Analysis of the Causes of War." In Donald Meltzer, ed., *The Collected Papers of Roger Money-Kyrle*, pp. 131–137. Perthshire: Clunie, 1978.

Nixon, Mignon. "War Inside/War Outside: Feminist Critiques and the Politics of Psychoanalysis." *Texte zur Kunst* 17, no. 68 (December 2007): 134–139.

Oe, Kenzaburo. *Hiroshima Notes*. New York: Marion Boyars, 1965.

Owens, Craig. "The Discourse of Others: Feminists and Postmodernism." In *Beyond Recognition: Representation, Power, and Culture*, pp. 166–190. Berkeley: University of California Press, 1992.

Plath, Sylvia. "Daddy." In Sylvia Plath, *The Collected Poems*, pp. 222–224. Ed. Ted Hughes. New York: Harper and Row, 1981.

"Questionnaire." *October* 123 (Winter 2008): 9–10.

Rancière, Jacques. *The Politics of Aesthetics*. Trans. Gabriel Rockhill. New York: Continuum, 2004.

Rhodes, Richard. *The Making of the Atomic Bomb*. New York: Simon and Schuster, 1986.

Robbins, Bruce, ed. *The Phantom Public Sphere*. Minneapolis: University of Minnesota Press, 1993.

Rose, Jacqueline. "Freud and the People, or Freud Goes to Abu Ghraib." In *The Last Resistance*, pp. 159–167. New York: Verso, 2007.

—— *The Haunting of Sylvia Plath*. Cambridge: Harvard University Press, 1992.

—— *The Question of Zion*. Princeton: Princeton University Press, 2005.

Sakai, Naoki. *Translation and Subjectivity: On "Japan" and Cultural Nationalism*. Minneapolis: University of Minnesota Press, 1997.

Segal, Hanna. "From Hiroshima to the Gulf War and After: Socio-Political Expressions of Ambivalence." In John Steiner, ed., *Psychoanalysis, Literature and War: Papers, 1972–1995*, pp. 157–168. New York: Routledge, 1997.

———— "Silence is the Real Crime." In John Steiner, ed., *Psychoanalysis, Literature and War: Papers, 1972–1995*, pp. 143–156. London and New York: Routledge. 1997.

Selden, Mark. "A Forgotten Holocaust: U.S. Bombing Strategy, the Destruction of Japanese Cities, and the American Way of War from the Pacific War to Iraq." In Yuki Tanaka and Marilyn B. Young, eds., *Bombing Civilians: A Twentieth-Century History*, pp. 77–96. New York: New Press, 2009.

Sherry, Michael S. *The Rise of American Air Power: The Creation of Armageddon*. New Haven: Yale University Press, 1987.

———— "The United States and Strategic Bombing: From Prophecy to Memory." In Yuki Tanaka and Marilyn B. Young, eds., *Bombing Civilians: A Twentieth-Century History*, pp. 175–190. New York: New Press, 2009.

Theweleit, Klaus. *Male Fantasies*, vol. 1: *Women, Floods, Bodies, History*. Minneapolis: University of Minnesota Press, 1987.

Toufic, Jalal. "Forthcoming." In *Forthcoming*, pp. 46–75. Berkeley: Atelos, 2000.

Turim, Maureen. "Childhood Memories and Household Events in the Feminist Avant-Garde." *Journal of Film and Video* 38 (Summer/Fall 1986): 86–92.

———— *Flashbacks in Film: Memory and History*. New York: Routledge, 1989.

Virilio, Paul. *War and Cinema: The Logistics of Perception*. New York: Verso, 1989.

Wigley, Mark. "Insecurity by Design." In Michael Sorkin and Sharon Zukin, eds., *After the World Trade Center: Rethinking New York*, pp. 69–85. New York: Routledge, 2002.

Willis, Sharon. *Marguerite Duras: Writing on the Body*. Urbana: University of Illinois Press, 1987.

Yoneyama, Lisa. *Hiroshima Traces: Time, Space, and the Dialectics of Memory*. Berkeley: University of California Press, 1999.

Young, Iris Marion. "Impartiality and the Civic Public: Some Implications of Feminist Critiques of Moral and Political Theory." In Seyla Benhabib and Drucilla Cornell, eds., *Feminism as Critique*, pp. 57–76. Minneapolis: University of Minnesota Press, 1987.

Young, Marilyn B. "Bombing Civilians: From the Twentieth to the Twenty-First Centuries." In Yuri Tanaka and Marilyn B. Young, eds., *Bombing Civilians: A Twentieth-Century History*, pp. 154–174. New York: New Press, 2009.

Žižek, Slavoj. "Are We in a War? Do We Have an Enemy?" *London Review of Books* 24, no. 10 (May 23, 2002): 3–6.

Zummer, Thomas. "Leslie Thornton." In Rolando Caputo and Scott Murray, eds., *Senses of Cinema*, November 2002, http://www.sensesofcinema.com/contents/directors/02/thornton.html; accessed May 28, 2008.

index